D1189312

DIGITAL
PHOTOGRAPHER

Collins

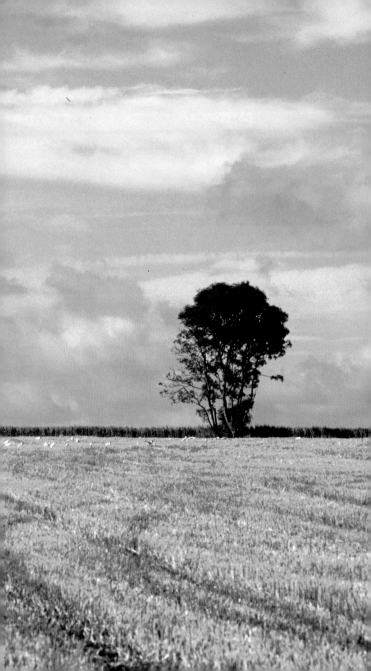

DIGITAL
PHOTOGRAPHER

Steve Bavister

Collins

First published in 2008 by
Collins, an imprint of
HarperCollins Publishers
77–85 Fulham Palace Road
Hammersmith, London W6 8JB

www.collins.co.uk

Collins is a registered trademark of HarperCollins*Publishers* Limited

12 11 10 09 08
 5 4 3 2 1

A catalogue record for this book is available from the British Library.

Conceived and created by Focus Publishing, Sevenoaks, Kent
Project manager: Guy Croton
Editor: Vicky Hales-Dutton
Designers: Heather McMillan, Marc Marazzi
Indexer: Caroline Watson

ISBN: 978-0-00728739-0

Printed and bound in China by Imago

CONTENTS

Photography means different things to different people. For some it is a way of capturing memories – of having a lasting reminder of special moments. For others it is a way of expressing themselves artistically. For a fortunate few, it is a rewarding way of earning a living. But for many it is simply one of the most fascinating hobbies there is to be enjoyed – a delicious blend of art and science that can be practised on its own or combined with other pastimes.

Equipment Matters

One of the secrets of success is choosing the right camera. Most of us now have one built into our mobile phone – and increasingly as digital resolution improves the quality of images produced is perfectly acceptable at relatively small degrees of enlargement. However, camera phones are extremely limited. While it is convenient to have them immediately to hand, so you can take pictures as and when the opportunity arises, they lack the versatility of dedicated cameras.

For this reason, those who are serious about taking good pictures tend to spend as much as they can afford on equipment, rather than making do with what they have already. At the very least, you need a compact camera with a decent zoom lens, and ideally a Single Lens Reflex camera with a collection of interchangeable lenses and other accessories. While you can tackle most popular subjects successfully with a compact camera, the tool of

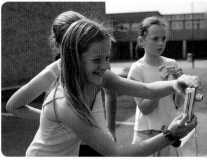

Start them young! Photography appeals to people of all ages, and because modern cameras are so easy to use, it is possible to get great results from the word go.

choice for serious photographers is an SLR, onto which you can fit everything from wide-angle lenses to open up perspective, and get more into the frame, to telephoto lenses that enable you to pull in distant subjects and compress perspective.

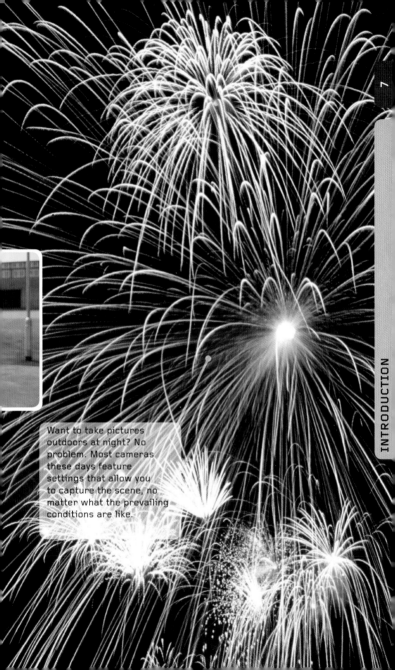

Want to take pictures outdoors at night? No problem. Most cameras these days feature settings that allow you to capture the scene, no matter what the prevailing conditions are like.

Developing Your Technique

Equipment, though, will only take you so far. Ultimately it is developing your technique that will determine how good your pictures are. And that comes to down to a number of key photographic skills: control over exposure; accurate focusing; effective composition; and powerful use of lighting.

Once you have mastered the different exposure 'modes' you will be able to put the right amount of light on the sensor or film in your camera in the most creative way – varying the shutter speed and aperture according to what you are seeking to express. You will also learn to recognize the kinds of situations in which exposure meters are most likely to be misled and get things wrong – and then what you can do about it.

Focusing, too, can sometimes be tricky. It is fair to say that modern, advanced focusing systems work well most of the time; however, if you are not careful, they will sometimes focus on the wrong part of the subject. Consequently, you need to know when to override automatic operation in your camera and take control yourself.

Effective Composition

Effective composition is at the heart of successful photography. Faced with a particular subject, there are dozens of different ways in which the elements could be arranged in the frame. Of course, much of this is down to personal taste and choice –

Creative use of lenses and composition makes it possible to turn a mundane scene into a picture with lots of impact. Here, the railway tracks disappearing into the distance combined with the fluffy white clouds on a blue sky create a memorable image.

after all, it's your picture! However, if you follow a few simple rules – such as using frames, dynamic diagonals and lead-in lines – your picture-taking will improve immeasurably. Colour, too, is crucial, and the way you blend tones can make or break an image.

As you become a more experienced photographer, you will also need to learn how to make the most of

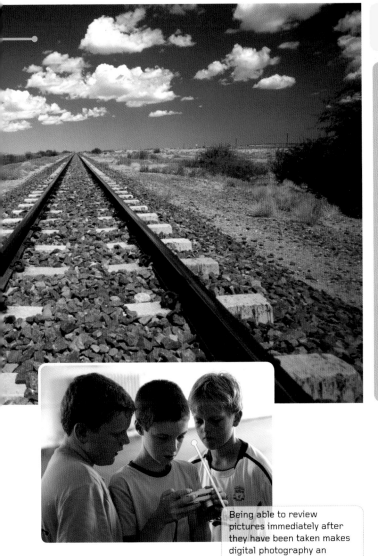

Being able to review pictures immediately after they have been taken makes digital photography an extremely sociable activity.

Biting sharpness and phenomenal precision are the characteristics of the high-resolution digital cameras now available. Here, every detail of the face of this street performer is clearly visible.

Single Lens Reflex (SLR) cameras are the first choice for professionals and enthusiasts because of the sheer versatility that they offer and the quality of results they deliver. They are now as good as the best film cameras.

the many moods and nuances of daylight. Once you understand how light changes from dawn to dusk, from season to season, and according to the prevailing weather conditions, you will be able to match the right light to the right subject. Quality of light is more important than quantity of light in photography, and some of the best pictures are taken when ambient levels are low or at night. This requires excellent technique to avoid problems with camera-shake and exposure.

Making Better Images

Ultimately, becoming a good photographer is a matter of learning to make pictures rather than just take them. No matter what subject you like to shoot, you should always be looking for ways of improving what you find already there, not just accepting things as they are. Follow the advice given in Chapter Three: exploring original and eye-catching ways of capturing your subject will help your images stand out from the crowd. The most popular subjects for

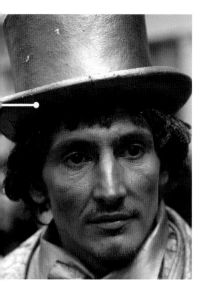

MANIPULATING IMAGES

Capturing your subject is only the beginning. Once you have transferred the image to your computer a whole world of creativity opens up. You can improve colour, exposure and composition, or selectively lighten and darken specific areas. Unwanted elements can be completely removed. Images can be combined, filters added to creative effect, pictures transformed into black and white or toned. Some of these options are explored in Chapter Six to get your creative juices flowing.

photography are people, landscapes, children, architecture and travel, and in this book we explore them fully, along with other subjects including sport and action, pets, close-ups, documentary and nude. As you learn specific techniques that are particularly effective in each area, so you will produce even better pictures.

Collins Digital Photographer has been designed so that you can either read it from the front to the back or dip into each of the sections as you prefer – to find the information you need to become a better photographer. We have sought not only to give you clear, practical advice but also to include inspirational, powerful pictures as a spur to your creativity. Enjoy your photography!

INTRODUCTION

1

BASICS

Everybody takes pictures – and virtually everyone now shoots digitally. The medium offers many advantages, and it is easy to see why digital has replaced film. You can view your pictures immediately, and digital images are incredibly accessible when you transfer them from the camera. But let's start with the basics: what do you need to begin taking great images?

Digital compact cameras are small, portable and inexpensive. They are easy to use for beginners as well as being ideal 'go anywhere' cameras for more experienced photographers.

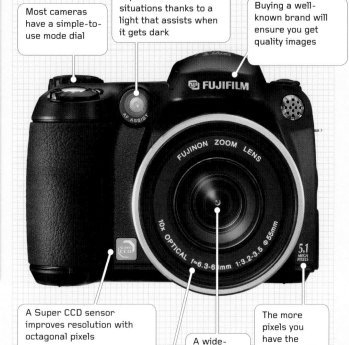

Most cameras have a simple-to-use mode dial

Fast, accurate focusing is possible in all situations thanks to a light that assists when it gets dark

Buying a well-known brand will ensure you get quality images

A Super CCD sensor improves resolution with octagonal pixels

A wide-ranging zoom lens will give you plenty of picture taking options

The more pixels you have the better quality the finished picture will be

The faster the maximum aperture of the lens, the easier it is to take pictures in poor light

Megapixel Ratings

The 'megapixel' rating typically found on digital compacts is a rough guide to the picture quality you can expect, although this is not as important now as it was when digital imaging technology was first emerging. This is because these days digital photography has advanced so much that just about any camera will take a reasonable image, regardless of the number of megapixels that it advertises. Five megapixels will give you excellent 6" x 4" prints and good enlargements up to 7" x 5" or even 10" x 8". If you regularly want to print at larger sizes, go for a higher-resolution camera with 7–10 megapixels.

Zoom Ranges

How long a zoom range do you want? Basic digital cameras usually have a '3x' zoom range. In other words, this means that at the maximum telephoto setting you get a 3x magnification compared to the wide-angle setting. If you want to shoot subjects which are further away, you need a longer zoom range. Some compact cameras have zoom ranges up to 6x, but if you want

LCDs

The LCDs (liquid crystal displays) on all digital cameras – from mobile phones to high quality SLRs – offer the advantage of instant display of your image, the moment it has been taken.

more (10x or 12x), you should look for a 'superzoom' camera, though these are generally bulkier.

Tips for Basic Usage

Most compact digital cameras are designed for simple snapshot operation, and control the shutter speed and aperture automatically. If you want to control these manually, you will need to look for cameras with 'PASM' (Program AE, Aperture-priority, Shutter-priority and Manual) modes.

SMALL, HANDY DIGITAL COMPACT CAMERAS ARE IDEAL FOR CAPTURING IMPROMPTU MOMENTS AND EVERYDAY EVENTS.

Check the battery life of your compact. Some cameras may take as few as 100–150 shots on a single charge, which is not always enough for a full day's shooting. Aim for a battery life of 200 shots or more.

Here are a couple of tips you can use in order to take better shots. Firstly, use the LCD to compose shots when you can, rather than the camera's optical viewfinder. Optical viewfinders are good in bright light, when the LCD can become hard to see, but they do not give an accurate indication of the precise area that the camera will photograph.

You will also notice that compact digital cameras suffer from 'shutter lag', in which case you press the shutter release, but the shutter does not fire straight away. This can make it difficult to time your shots accurately. To get around the problem, line up your shot first and then half-press the shutter button. The camera will focus and the focus will remain 'locked' while the button remains half-pressed. Now wait for exactly the right moment to take the shot, then press the button the rest of the way until it is fully depressed. The shot will be taken instantly, without any shutter lag.

HANDY CAMS

Digital compact cameras come in a variety of shapes and sizes. Choose one that will fit in a pocket or handbag and you will have it readily to hand whenever you want to take a picture.

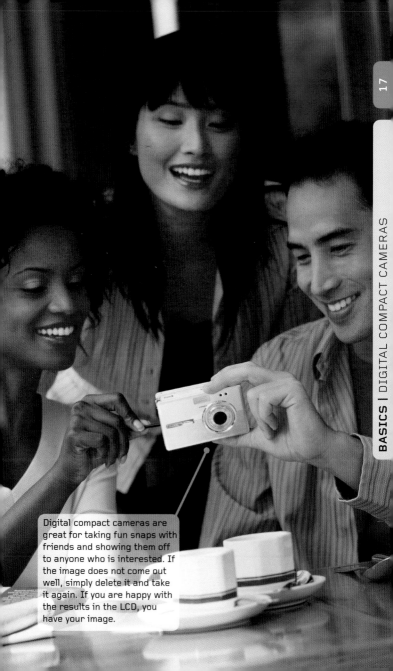

Digital compact cameras are great for taking fun snaps with friends and showing them off to anyone who is interested. If the image does not come out well, simply delete it and take it again. If you are happy with the results in the LCD, you have your image.

Digital SLRs are bulkier and more expensive than compact digital cameras, but they have larger sensors which give better picture quality and more advanced photographic controls.

A standard zoom is supplied with most digital SLRs

A top-plate LCD panel keeps you informed of key shooting data

Despite their size, most digital SLRs are not too heavy, thanks to the use of poly-carbonate

The shutter release button is carefully positioned for the right index finger

Most digital SLRs feature a chunky mode dial

Some DSLRs have a built-in flashgun – others have a hot-shoe that allows an accessory gun to be fitted

HANDLING AN SLR

Digital SLRs are much bigger and heavier than digital compact cameras, which means you cannot just slip one into a pocket or a handbag – you need to make a conscious, deliberate decision to carry one around with you, especially if you want to have the option of using more than one lens, or fitting an external flashgun. In that case, you will need to pack everything into a bag. Unless you have extremely small hands you will find that SLRs – despite their size and weight – handle extremely well, with their chunky handgrips.

While digital compacts are fine for snapshots, a digital SLR is required if you want to create more advanced images such as this stunning still-life study.

What is an 'SLR'?

The acronym SLR stands for 'Single Lens Reflex'. When you use an SLR, the picture is composed and taken through the camera's single lens. 'Reflex' refers to the mirror which is used to reflect the image up into the viewfinder until the moment the shutter is released. The mirror flips up and the image then passes to the sensor at the back of the camera.

Low-cost digital SLRs have 6–10 megapixel sensors which can yield very good results, but it is worth paying a little extra for a camera with more pixels. The difference in fine detail is visible.

Lenses, Kits and Accessories

You can use different lenses on a digital SLR and manufacturers sell them in 'body-only' form, in which

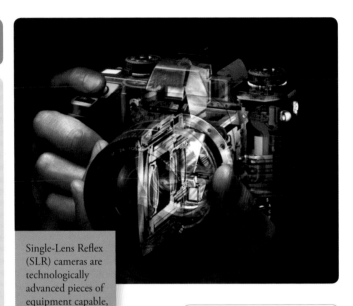

Single-Lens Reflex (SLR) cameras are technologically advanced pieces of equipment capable, with the right lens or accessory, of taking virtually any picture you could imagine.

Ergonomically designed controls make it possible to navigate features quickly and easily

Digital SLRs have an optical rather than an electronic viewfinder

Having a large monitor makes it easier to review and evaluate images

More advanced models offer a wide range of sophisticated features

case you have to buy a lens separately, or as a camera 'kit', when a general-purpose zoom lens is included. If you already own compatible lenses, it might make sense to buy the body on its own. However, if this is your first digital SLR, you should get a kit with a lens included. This will be much cheaper than buying the body and the lens separately.

The Benefits of SLRs

Digital SLRs are as easy to use as compact digital cameras. All have 'point-and-shoot' fully automatic modes, so beginners can explore the more advanced options at their own pace. Having said that, it may be necessary to modify your shooting technique a little if you are used to a compact digital camera. This is because digital SLRs have much less depth-of-field (near-to-far sharpness) than compacts, so when you graduate to an SLR you will need to get to grips with lens apertures and how these affect depth-of-field. SLRs also have faster focusing systems than compacts, so there is less risk of shutter lag.

Finally, because the pictures are sharper than those from compacts (and digital SLR users will be expecting more from their photos anyway), it is a good idea to invest in a tripod to help avoid camera-shake in low light and to aid careful composition whenever time and space permit.

Input dials such as this one are used to select settings such as shutter speed and apertures

Leading brands can be relied upon to give you quality results

The rounded handgrip makes digital SLRs comfortable to hold

YOU CAN TAKE GREAT IMAGES ON AN AFFORDABLE DIGITAL SLR WHICH CAN BE BLOWN UP TO A3 AND BEYOND.

Many photographers want a wider zooming range or more photographic control than an ordinary compact digital camera can provide, yet they do not want the size and weight of a digital SLR.

Alternative Cameras

A 'bridge' camera may be the answer. These offer many of the advanced controls of digital SLRs but in a smaller and less expensive body with a fixed lens. This lens may offer a very wide zoom range, perfect for photographers who want a single, 'all-in-one' camera.

Camera phones are becoming more popular, but the picture quality is still not of the standard you would expect from even a basic digital camera. Another alternative is to use a camcorder – most will take stills as well as video footage – but again, image quality can be an issue.

Most camcorders offer the option of capturing still images, but their resolution is relatively low and unsatisfactory.

The cameras built into mobile phones are increasingly capable of delivering images of acceptable quality. However, they lack the resolution and versatility of dedicated compact and SLR cameras.

OTHER MEDIA

Most images from a camcorder are only 1–2Mb or so in size, which means that the quality is a long way short of what you get from a digital camera.

Images taken with a mobile phone look fine when reproduced reasonably small, but as soon as you enlarge them they appear 'soft' and lacking in sharpness.

Single lens reflex cameras enable you to change lenses to achieve a variety of effects. The camera's standard lens will give an angle of view roughly similar to that we perceive with the naked eye, a wide-angle lens enables you to get more into the frame, while a telephoto magnifies distant objects.

Lens Properties

There are other lens properties to take into account, apart from their focal length, including the maximum aperture. The larger the maximum aperture, the more light the lens can gather. This is useful in poor light or whenever you want shallow depth-of-field in your photographs.

Zoom Lenses

In modern cameras, zoom lenses have largely taken over from lenses with fixed focal lengths ('prime' lenses). The versatility of zooms means that you do not have to carry around a number of different prime lenses, or keep changing lenses for different subjects. However, zoom lenses do have a couple of intrinsic disadvantages. One is that their maximum apertures are lower than those of prime lenses. Whereas a 50mm prime lens might have a maximum aperture of f/1.8, a typical 'standard zoom' might have a maximum aperture of f/4 at this focal length.

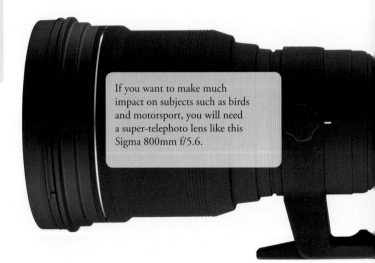

If you want to make much impact on subjects such as birds and motorsport, you will need a super-telephoto lens like this Sigma 800mm f/5.6.

Fast aperture telephoto lenses are bulky, heavy and expensive – but ideal if you want to capture subjects such as sport and action.

Fish-eye lenses have such a wide angle of view that you have to be careful not to get your feet in the picture.

For general use, nothing beats a telephoto zoom with a range of around 70–300mm.

Photographers who favour subjects like architecture and landscape should consider investing in a wide-angle zoom.

Lens Mounts

Each digital SLR brand uses a different lens mount. A Nikon lens, for example, will not fit a Canon camera. However, you do not have to buy lenses made by your camera's maker. Independent companies such as Sigma, for example, make lenses which can be supplied in different mounts according to the brand of camera you are using. These lenses are just as serviceable as those supplied by leading camera firms.

Independent Lenses Versus Marque Lenses

Lenses made by independent companies are generally much cheaper than those offered by the camera maker. The optical performance is often very good and it may be difficult to see the difference in image quality between photographs taken using a good-quality independent lens and those taken on a more expensive

'marque' lens. Having said that, when you buy a lens you are not just paying for image quality. Marque lenses may be better made than those from independent companies and are consequently more likely to withstand years of hard use. Their design and finish will be consistent with other lenses in the same range, and with the camera bodies which they are designed to accompany, and the lens range may include more sophisticated and specialized lenses that you cannot get elsewhere.

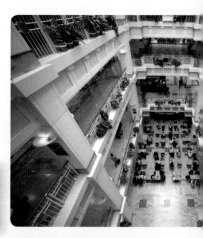

Of course these lenses can be used indoors as well – whenever you need an adaptable focal length.

EQUIVALENT FOCAL LENGTH

Photographers using 35mm cameras are used to judging the angle of view of a lens by its focal length. However, with a couple of exceptions, digital SLRs have physically smaller sensors, so that the angle of view of the lens is reduced and it appears to have a longer focal length. You need to multiply the actual focal length by a factor of 1.5 or 1.6 to get its 'effective' focal length. For example, on a digital SLR a 50mm lens effectively becomes an 80mm lens.

As the focal length of a lens increases, so its angle-of-view narrows. Wide-angle lenses take in lots of the scene because they have a large angle-of-view. With super-telephoto lenses the angle is reduced to just a few degrees, and little of the scene is included.

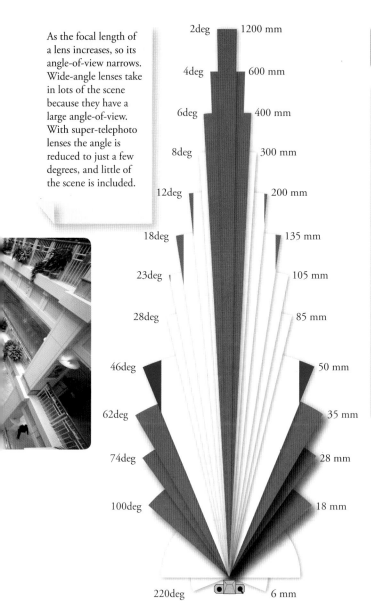

2deg — 1200 mm
4deg — 600 mm
6deg — 400 mm
8deg — 300 mm
12deg — 200 mm
18deg — 135 mm
23deg — 105 mm
28deg — 85 mm
46deg — 50 mm
62deg — 35 mm
74deg — 28 mm
100deg — 18 mm
220deg — 6 mm

2

THEMES

One of the most wonderful things about photography is that you never run out of subject matter. There are so many different themes to explore. Many people start with landscapes, portraiture, travel, wildlife, children and architecture – and there is enough there to keep you going for a good many years – but the world is your oyster and you can try anything that appeals.

If you want some great landscape shots, a willingness to spend time exploring the countryside on foot is vital. The best views are rarely found at the roadside, so be prepared to get away from the car or coach. Only by going off the beaten track with a map in your hand will you discover things that many photographers miss.

Ideal Conditions

Successful landscape pictures can be taken at any time of the day, but certain conditions stack the odds of success in your favour. If you rise at dawn you are almost certain to capture some stunning images as the earth awakens after a night under the stars. From high ground you will often see veils of mist hanging in valleys, or floating gracefully over rivers, lakes and woodlands. The first rays of sunlight bathing a hillside

USE A TRIPOD

One of the keys to producing great scenic pictures is to use a tripod. It will ensure you get sharp pictures and will also slow down your picture taking – resulting in more considered compositions.

also look stunning, and the low angle of the light reveals texture and creates a sense of depth.

However, although bright sunshine and blue skies promise great conditions for shooting landscapes, nothing beats a bit of stormy weather if you want really dramatic images. The most spectacular images are produced when rays of sunlight break through a dark, brooding sky and illuminate the foreground or distant features.

Placing one of these dramatic looking trees so that it looms large in the foreground gives the picture a powerful sense of depth.

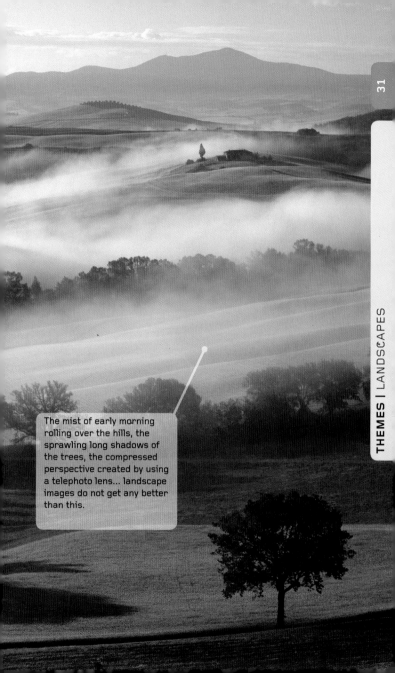

The mist of early morning rolling over the hills, the sprawling long shadows of the trees, the compressed perspective created by using a telephoto lens... landscape images do not get any better than this.

The most important thing with landscape photography is not to include too much. Faced with a great expanse of gorgeous countryside, you may be tempted to just start snapping away. However, when there is too much in the frame you can lose impact. Start, then, by deciding what it is about the scene that attracts you. Maybe the light on the hills catches your eye or the pattern created by a dry stone wall? Once you have established what the main point of interest is, you can set about emphasizing it. As a rule of thumb, keep your compositions simple. A single feature, such as a cottage at the foot of a mountain, can make an attractive shot in its own right.

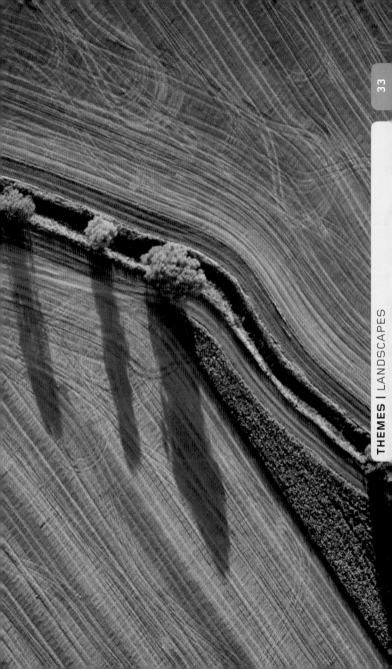

A large proportion of the earth's surface is covered with water, so it is not unreasonable to think of it as a subject in its own right, as we do landscape. After all, what a range of options it offers us: waterfalls, rivers, lakes, reservoirs, pools – plus, of course, the sea.

Photographing Water

The appearance of water is determined largely by the quality of the light and the colour of the sky. Shoot at different times of day and in a variety of different weather conditions and you get a wide range of results. In bright, sunny conditions, rivers and lakes tend to look blue, whereas early or late in the day they take on an attractive warm coloration. The position of the sun also plays a role. When it is overhead, around noon, a highly reflective finish is produced, with lots of highlights dancing on the surface. But during the morning or afternoon, when the sun is at a lower angle, light rakes across the surface, revealing the texture of the water. Best of all, though, is a sunset over water – which is closely matched by the delightful colours you get an hour or so after the sun has gone to sleep.

ON REFLECTION

One of the first things that comes to mind when you think of water is reflection (see right). From perfect mirror images in a tranquil lake to shimmering abstracts in a bustling harbour, reflections make great subjects. Use a wide-angle lens if you want to include both the reflection and what is being reflected, or a telephoto zoom to crop in on just a small area.

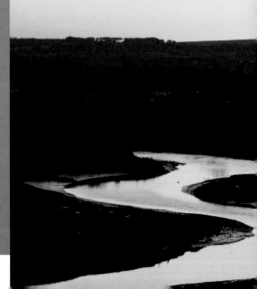

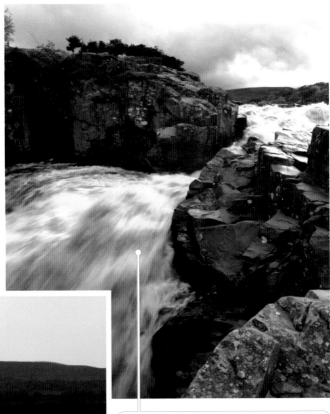

Moving water has immense power and the most effective way of capturing it is by setting a long shutter speed. The result is an atmospheric, creamy froth that flows effortlessly around rocks or plummets earthward from a waterfall (see above). The longer the exposure, the greater the degree of blur. Start by mounting your camera on a tripod, then experiment with a range of shutter speeds, to see what works best – this will often be in the range of ¼ second to 4 seconds, which will require a slow ISO setting.

Action is one of the most challenging subjects to photograph. As well as having to worry about all the normal things – such as exposure, lighting and composition – you also need to focus accurately on something that is moving, possibly so fast that you can hardly see what's going on.

Shoot Everyday Action

While it is natural to equate action with sport, in fact it is only the tip of the iceberg. A better approach is to think of action as capturing movement, and no matter where you live you will find opportunities to take great action pictures. So do not ignore the more common subjects that are around you every day – such as your kids jumping off a trampoline in your garden or skateboarders honing their skills on the street.

By far the trickiest part of focusing is keeping a moving subject in sharp focus. Happily, most autofocus cameras will handle this chore for you – and many have a 'predictive' capability that anticipates where the subject will actually be when the shutter fires.

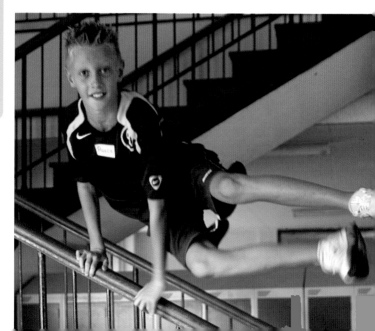

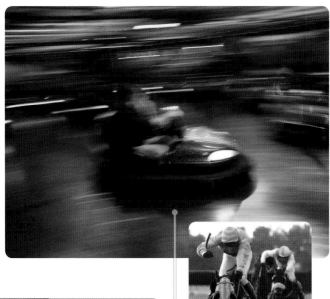

ACTION!

Action is all around us – and can be just as captivating as sport. The slight movement in the jumping boy's legs makes this shot work effectively.

One of the best ways of representing action is by setting a long shutter speed and blurring the subject. These dodgem cars were photographed at ¼sec, with the camera panned to render the dodgem recognizable.

You need quick reactions, a reasonably long lens, and a shutter speed of at least 1/500sec to capture racehorses galloping towards you. Get it right, though, and the results can be spectacular.

Photographing Winter Sports

Special considerations when shooting winter sports include the need to check the exposure carefully. Snow is white. To a human, such a statement is obvious; however, to a camera, it is not. When it is pointed at snow, the camera simply 'sees' a great deal of light and reduces the exposure to compensate. The result is dingy, dirty snow and figures which come out far too dark. One solution is to leave the camera set to automatic exposure, but apply an EV compensation value of +1EV to +1.7EV, depending on the camera and the prevailing conditions. Alternatively, set the camera to manual mode, take a meter reading from a subject in the same lighting and use this exposure for your photographs.

PANNING

Panning is a very successful technique for conveying a sense of movement.

1) Choose your viewpoint
Firstly, prepare carefully for the shot. Plan where you are going to stand to get the best view of your subject. Think about the background as well, and try to pick one without too much detail.

2) Set a slow shutter speed
You may need to experiment with shutter speeds to find the one which offers the best compromise between background blur and still keeping the subject acceptably sharp. Start with a shutter speed of 1/30sec and work up or down as necessary.

3) Match the camera movement to the subject
The next part is the most difficult. You need to follow the subject with the camera as it passes, releasing the shutter as you do so. You will need to practise to discover the right timing for the shutter release. On your first attempts you may find that you are releasing it too soon or too late.

You need a long telephoto lens, a shutter speed of 1/1000 sec, and perfect timing to capture images like this...

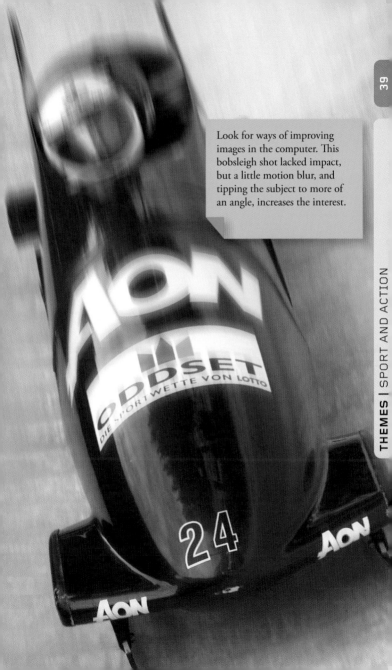

Look for ways of improving images in the computer. This bobsleigh shot lacked impact, but a little motion blur, and tipping the subject to more of an angle, increases the interest.

Tricky subjects like this, in which there is movement towards the camera, require fast, accurate autofocusing systems that can predict where elements of the picture will be at the point at which the shutter actually fires. Without these, parts of the image would almost certainly come out blurred, which would destroy what is otherwise an arresting photograph.

Many cameras are bought in order to photograph holidays, trips overseas and days out. All photographers, experienced or otherwise, will want to record these events.

Be Selective

While it is tempting to photograph anything and everything that catches your eye in an indiscriminate fashion, a little planning and attention to detail will produce a much more satisfying visual record. The obvious candidates for photography are local views and landmarks. The postcards in the tourist shops can give you some great ideas for locations and viewpoints. However, look for a new angle on the scene and include yourself or other members of the party in the photography to give it a more personal appeal in the future.

Additionally, be careful that you do not simply photograph 'things'. Holidays and outings are not just about the places you visit – they are also about the things you do while you are there. Consequently, make sure that you record your activities as well as local sites of interest.

Think Before You Shoot

Travel 'light', and this does not stop at limiting the weight of the equipment you take with you. You should also travel 'light' in a mental sense, sticking to a simple camera that you can operate without concentrating (you will have other things on your mind), when the time comes to take your picture.

USING LIGHT

One of the great things about being on holiday is that you have the freedom to take pictures when the light is at its most perfect, because you can be out with your camera at any time of day. This dramatic photograph was taken just as the sun was about to disappear over the horizon.

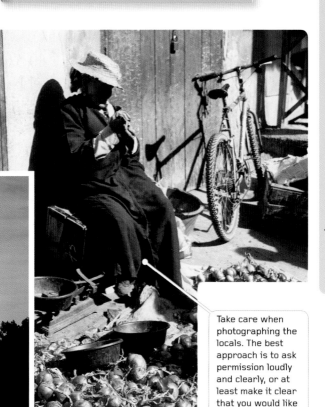

Local people can make great subjects for your photographs, and we have all seen many appealing and fascinating examples in magazines and photography books. However, it is important always to approach people with caution and, above all, respect.

Take care when photographing the locals. The best approach is to ask permission loudly and clearly, or at least make it clear that you would like to take a picture. Always bear your subject's feelings closely in mind.

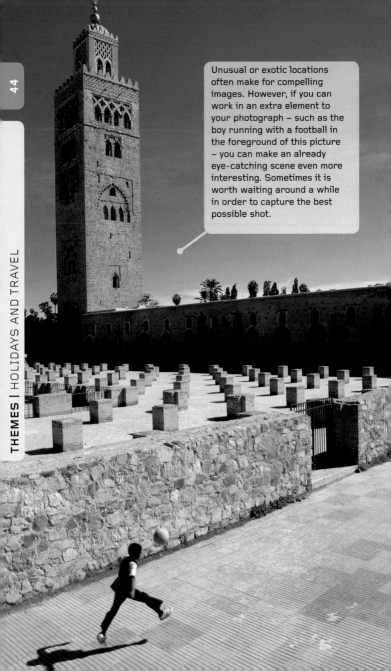

Unusual or exotic locations often make for compelling images. However, if you can work in an extra element to your photograph – such as the boy running with a football in the foreground of this picture – you can make an already eye-catching scene even more interesting. Sometimes it is worth waiting around a while in order to capture the best possible shot.

Protect Your Equipment

You should also consider the security of your photographic equipment when you are taking photographs while abroad. While branded camera bags are a neat lifestyle accessory, they can also serve as a blatant advertisement for thieves in many places. Plain, unbranded camera bags are generally a safer bet. Try to avoid waving your camera around in too obvious a fashion or leaving it in plain view on a strap around your neck, for example. Straps offer a level of security against pickpockets, but expensive and highly visible camera gear may also tempt muggers, which can result in much more serious problems.

Cameras may need protection from the elements as well, especially on trips to the beach. Keep your camera in a bag and place it carefully on a beach towel or a chair whenever it

Always be on the lookout for subjects that give a flavour of the place you are visiting. For example, Las Vegas makes people immediately think of wedding chapels, so why not take a picture of one of these, or the inevitable garish sign advertising its services?

is not actually in use. Sand quickly gets into knobs, dials and seams in camera bodies and can be next to impossible to get out again. Of course you want to be able to take photographs in such situations, but care and thought is required. The same applies to any other equipment you take with you. Lenses, lighting aids, tripods and other supports are all expensive items of kit which should last you years if they are looked after properly. However, one overly casual visit to the beach on a windy day could change all that and could prove an expensive mistake in the long run.

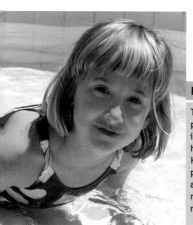

KIDDY PIX

Taking pictures of children playing on the beach or in a pool is an essential part of summer holidays for many people. However, make sure that you protect your camera from sand and water, so that these images remain evocative for the right reasons!

Photographing wild animals is by its very nature more of a challenge than taking pictures of your pets at home — but it can be extremely rewarding. The key to good shots of wildlife is patience, combined with luck and practice.

Wildlife

Venturing into the countryside to photograph animals in the wild for the first time can be an exciting experience, but also a disappointing one. Most species quite sensibly stay well away from people, so you need an extremely powerful lens to stand any chance of filling the frame. At the right time of day you may have success with rabbits and deer, but animals such as foxes and badgers may prove elusive unless you have specialist knowledge of their habits and habitats. To stand any chance at all you will need to wear drab clothes, avoid aftershave or perfume, and move slowly and carefully.

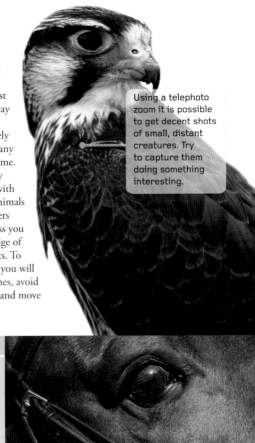

Using a telephoto zoom it is possible to get decent shots of small, distant creatures. Try to capture them doing something interesting.

CLOSE-UPS

Powerful close-ups can be created using an ordinary telephoto zoom — as in this dramatic photograph of a horse's eye.

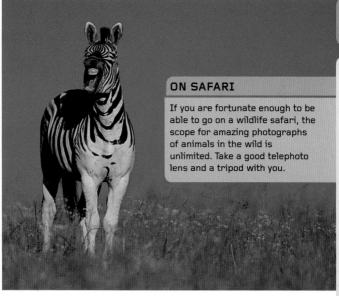

ON SAFARI

If you are fortunate enough to be able to go on a wildlife safari, the scope for amazing photographs of animals in the wild is unlimited. Take a good telephoto lens and a tripod with you.

Birds

Wherever you live, there is a pretty good chance you will be able to take pictures of birds – possibly without even having to leave your house. Though you may not find exotic species like golden eagles in your garden, you will probably have sparrows, thrushes and robins around you in abundance. With a reasonably powered telezoom that goes up to 300mm, you will be able to get a decent-sized image – which subsequently may need cropping and enlarging in the computer to fill the frame. However, birds have far greater appeal when they are on the wing. But capturing them in flight

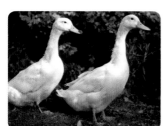

Small birds can be tricky to photograph well, but larger species, such as ducks, can be photographed readily where there is plenty of water.

GETTING UP CLOSE

Move slowly and steadily and you should be able to get reasonably close to deer in parks and gardens. Very often they are quite used to people and will not scare too easily.

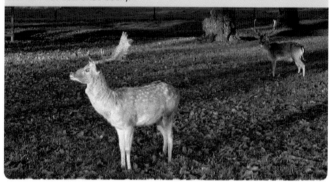

can be far from easy, especially in the case of small species that travel at great speed, such as swallows and swifts. To get good pictures of birds like these, you need fast reactions. Your best bet, therefore, is to get out and about and find some larger birds, such as geese, ducks or gulls, which are slower and more graceful in flight.

If you go to a park, the birds will be used to humans coming and going, and are consequently less likely to be scared away. This is a good way to begin taking pictures of birds and to accumulate valuable experience without complications. Toss the park birds some bread or seeds and you will be able to photograph them as they come in to land or take off.

Always make sure you choose a vantage point in relation to the background and direction of light which shows the subjects at their best. All birds move relatively quickly, so you need to be prepared.

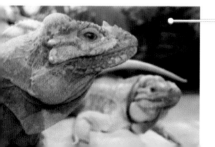

Exotic creatures such as this brightly coloured iguana lizard can make good subjects. Go to your local zoo or safari park and experiment.

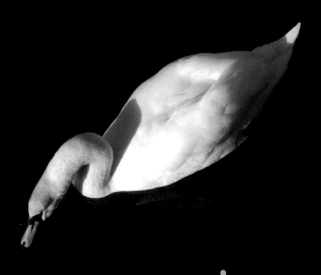

If your subject is relatively slow moving, like this languid swan, it is possible to set up a shot in a more leisurely fashion, in order to make the most of the prevailing light and colours. The contrast here between the white bird and the black water is striking.

Pets are one subject where fancy techniques are not required; just fill the frame with your subject and fire away. Remember, though, that animals are not always the easiest subjects to work with.

Photographing Your Pets

Many people regard their pets as part of the family – and photograph them along with the rest. Getting good shots of Felix or Rover is relatively easy – because they are always around. The secret lies in having your camera loaded with film or with its battery charged and ready for use at a moment's notice. That way you can react as soon as you see the potential for a good photograph.

As far as possible, you should avoid the use of flash, as this can bounce back from your pet's eyes, producing the canine or feline equivalent of human red eye. Instead, go for an ISO400 setting and try to take your pictures when there is a reasonable level of light.

Spontaneous, natural, pictures are often the best, but there is nothing to stop you setting up a more posed

LIGHTING TIPS

Animals generally do not like bright lights and will often react badly to flash guns. The key is to ensure that the room is well lit and your pet is comfortable.

shot – the way you would shoot a portrait of a person. Once again, you need to work in good light, so that flash is not required, but you should also seek out a plain backdrop, such as a wall, to help concentrate attention on the subject.

Perfect Timing

One of the best times to photograph animals like cats and dogs is when they have just eaten – they are less likely to be energetic and more likely to stay in one place. That said, you might prefer to take some action shots – of a dog jumping in

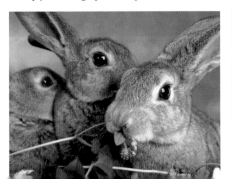

Some pets – such as these rabbits – scare easily and can be difficult to capture well. Give such subjects food to put them at ease.

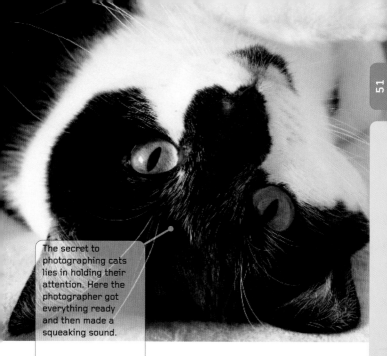

The secret to photographing cats lies in holding their attention. Here the photographer got everything ready and then made a squeaking sound.

Dogs can be great subjects for pet photography because they like showing off and will often play to the camera. Give them props, and they will have even more fun!

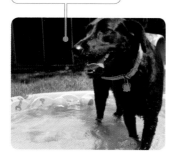

the air to catch a stick, or maybe a cat chasing a toy mouse.

What technique do you use if you have a different kind of pet? It depends on a number of factors, including how big it is, how active it is and how tall it is. With smaller animals, such as hamsters, gerbils or tarantula spiders, you may need to get in closer to be able to fill the frame. In the case of creatures such as rabbits or ducks, you can stand further away and use a telephoto lens. If you are the proud owner of something more exotic – a snake or a gecko, for example – you will need to adapt your photography according to its habits. Take a broad range of images at first, including some of the pet with its owner.

EXPRESSION

The faces of animals can
feature expressions, just as
well as those of human beings.
This dog seems to have a
superior, haughty manner that
is emphasized by the strong
eye contact it is making with
the camera lens.

These days pets come in all shapes and sizes – but do not feel you have to include all of them in the picture. Cropping in tight often produces a great deal more impact.

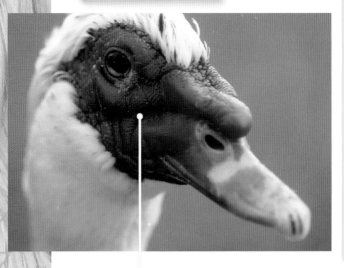

If you are taking close-up portraits of your pets – whatever kind of animal they may be – you want to capture their personality and individual character traits as far as possible, just as you would in a portrait of a person. Try a sequence of shots taken as close together as possible and then select the best ones.

Detail is important in good animal portraits. Every whisker, hair and pore can be clearly made out in this carefully composed image of a distinctly dubious-looking family hound.

Successful portrait photography is straightforward – providing you follow a few simple rules. With a little effort and thought it is possible to produce portraits that really stand out from the crowd, portraits in which the person actually seems to come alive in front of you.

The Best Approach

For a start, decide what kind of approach you are going to take. Do you want a posed picture, in which the person is looking at the camera, or a candid, where they are unaware that you are taking the shot? Posed pictures offer the advantage that you have more control, but the disadvantage that people often freeze, making it difficult to capture them in a natural way. One of the most important skills is 'connecting' with your sitter, so that they trust you and will open up for you.

Lighting Portrait Photography

In most cases soft lighting is best – the sort you get on a hazy day outside, or the light that streams in through a large window. Avoid strong, contrasty light, which produces heavy, unattractive shadows.

With candids you get pictures of people as they really are, but the lighting is not always ideal or the background is messy. Unless you are shooting an environmental portrait – such as a butcher in a butcher's shop – then it is a good idea to choose a plain, uncluttered backdrop that will not distract.

HOW TO FLATTER

· Long/large nose
Shoot with a longer focal length than normal – 200mm to 300mm. The foreshortening of perspective flattens the nose. Shoot from head-on, rather than from the side.

· Double chin
A slightly higher than normal shooting angle does the trick here, because the neck is partially obscured. Asking the person to push their chin out slightly can also help.

· Wrinkles
Illuminate your subject with soft light coming from behind you to play down wrinkles.

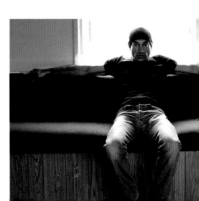

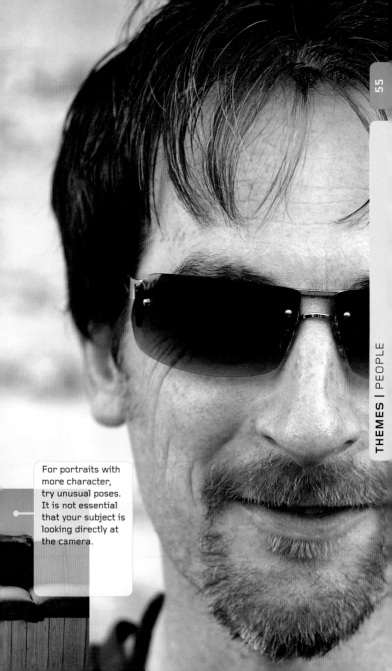

For portraits with more character, try unusual poses. It is not essential that your subject is looking directly at the camera.

One of the most challenging areas of portraiture is photographing couples and groups – because there is so much more to think about and attend to than with individuals.

Couples

There are dozens of effective ways of putting two people together, and really no 'right' or 'wrong' way. The most obvious manner in which to produce a feeling of connection is to have the two people touching. The options depend to a large degree upon the relationship between them. Whatever the relationship, get them close enough so that their bodies are in contact. This creates a nice, tight composition.

Groups

The most obvious way of posing three people is to have them standing in a row. But make sure everybody is touching shoulder-to-shoulder and smiling, or the group can end up looking like a firing squad! Done well, this can work effectively, but it is a rather static approach to an image. There is often a variation in the height of people, and it is a good idea to place the tallest person in the middle, creating a triangle effect.

LIGHTING

Unless you are taking pictures in which there is a lot of light, allowing you to set a small aperture of f/11 or f/16, you need to keep everyone roughly the same distance from the camera if they are all to be in focus.

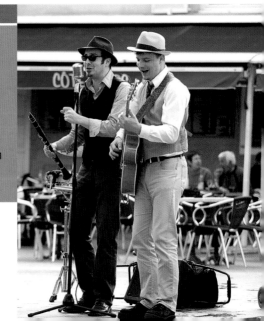

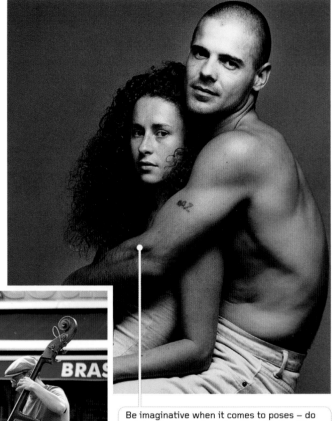

Be imaginative when it comes to poses – do not just have couples standing side by side.

Black and white photography can be very effective for portraits of friends and family. Something about the textures and shadows of monochrome can enhance the mood of an intimate shot and makes a nice change from more frequently seen colour portraits.

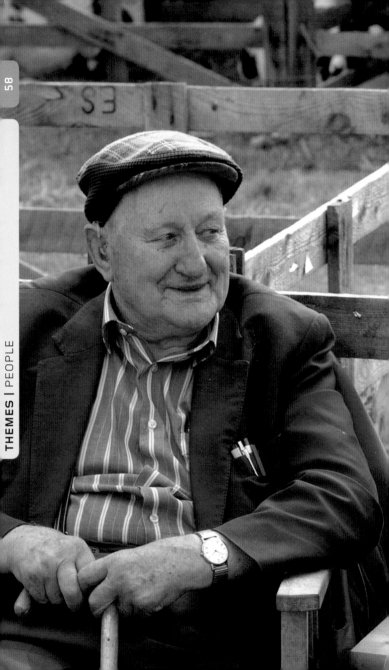

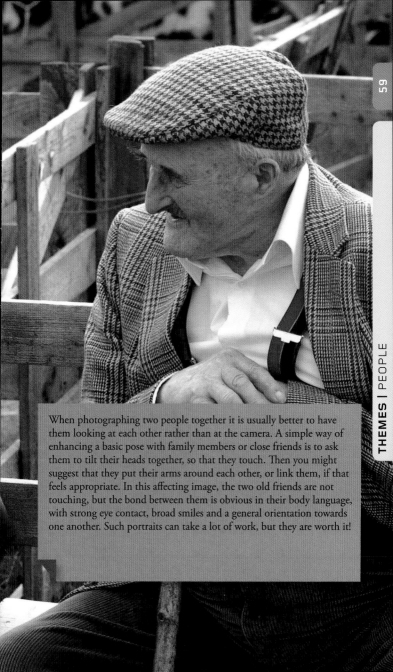

When photographing two people together it is usually better to have them looking at each other rather than at the camera. A simple way of enhancing a basic pose with family members or close friends is to ask them to tilt their heads together, so that they touch. Then you might suggest that they put their arms around each other, or link them, if that feels appropriate. In this affecting image, the two old friends are not touching, but the bond between them is obvious in their body language, with strong eye contact, broad smiles and a general orientation towards one another. Such portraits can take a lot of work, but they are worth it!

As with general portraiture, you can either pose babies and children or shoot candids. The best approach depends on how co-operative they are and their age and temperament.

Babies

An unhappy baby makes for a miserable photographer. To make life easy for yourself, take your pictures after the little darling has been fed, changed and settled. Then set everything up in advance, double-checking everything before you start taking pictures and only introducing the baby once you are ready. Young babies are easiest to photograph when they are asleep or held in the arms of an adult. Their head needs to be supported at all times, so keep a supply of cushions to hand.

Toddlers

Toddlers tend to make the most of the fact that they can walk, and enjoy nothing more than rushing towards you when you point a camera towards them. So you need to be quick or, more usefully, photograph them when they are doing something, such as playing with toys or a pet. Avoid shooting while looking down on them – you will end up with big heads, little bodies, and stretched necks. Get down to their level by crouching or sitting on the floor.

Infants

With slightly older children, from the age of five upwards, it is possible to go for a posed rather than candid picture. But do be aware that their attention span is extremely brief and they won't sit still for long.

Pointing a camera at some children inspires them to start playing around – and all you have to do is capture the action as it unfolds. Kids are full of life, so try injecting some energy into your picture taking. Do not make it boring and serious. Have some fun. Take them to a park or playground and get them to let off steam.

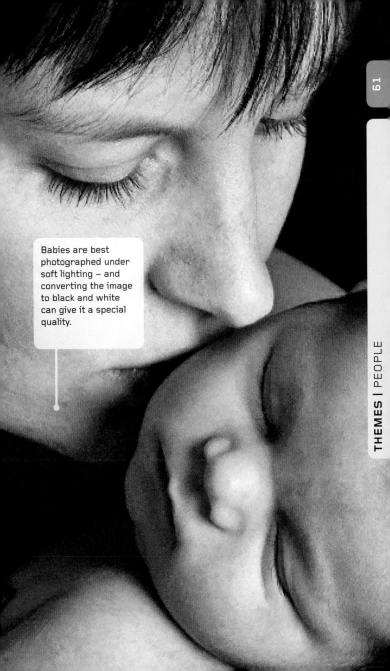

Babies are best photographed under soft lighting – and converting the image to black and white can give it a special quality.

When you think of architectural photography it is probably stately homes and skyscrapers that come immediately to mind – and with subjects like that you have certainly got a head start when it comes to capturing some great images. However, don't despair if you live in a small town or the heart of the country; there are photogenic buildings to be found pretty much everywhere.

Photographing Buildings

It's not just a matter of what you photograph, it is also how you photograph it. A simple country cottage or a semi-detached house in the suburbs have potential when photographed in the right way – and that's without considering the opportunities offered by office blocks, shopping centres, or even your local take-away.

The Importance of Light

One of the key factors to consider when photographing buildings is light. Few buildings look their best in overcast lighting, and it is usually a waste of time taking pictures

Generally it is a good idea to avoid photographing buildings in the middle of the day, when the sun is high in the sky, and casting heavy shadows downwards.

ARCHITECTURAL DETAILS

Architectural details can sometimes be more interesting than the whole of the building. They could literally be anything – from an unusual window to this feature on a bridge.

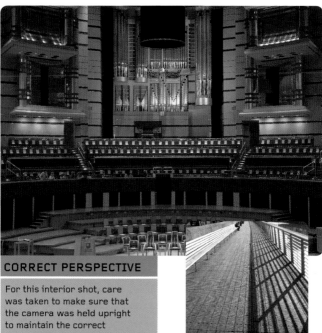

CORRECT PERSPECTIVE

For this interior shot, care was taken to make sure that the camera was held upright to maintain the correct perspective. Buildings should be photographed so that all the uprights are perpendicular to the side of the image. That means having the camera completely square when the photograph is taken. In practice it is often difficult to do that. Even with your widest lens fitted, the building or interior view may be too big or there may not be enough room to get far enough back to include it all in the frame. Telephoto lenses, though, are excellent for buildings in which there is plenty of room, allowing you to get further back and still fill the frame.

A wide-angle is considered the 'standard' lens as far as architectural photography is concerned – the wider the better. The ideal tool for anyone serious about photographing buildings and other structures is a wide-angle zoom, starting at 17mm or even wider. If this kind of photography is your thing, invest in the best wide-angle zoom you can afford.

of them under such conditions.
However, even the most ordinary
looking place can be brought to life
when bathed with a little sunlight.

Nevertheless, far more atmospheric
conditions can be found early in the
morning or late in the evening, when
the sun is lower, and also warmer in
colour than the bluer light which is
so often found around noon.

The angle of the sun is also
important. Best results are achieved
with the light striking the building
obliquely and bringing out the
texture of the materials used in its

construction. For many subjects,
there is nothing to beat the 'raking'
sunlight you often get at the end of
a bright day, which gives a strong
sense of depth. Placing the sun so
that it strikes the building head-on
will lead to flat and disappointing
results.

Take particular care when taking
pictures of buildings that are
especially light, such as those
painted white or made of pale
stonework – you may need to
increase your exposure slightly.
These features can easily cause
under-exposure.

3

TIME AND PLACE

The technology in modern cameras makes it easy to take pictures that are sharp and well exposed most of the time. However, they are far from foolproof. You still need to keep your wits about you if you are to be sure that your 'once in a lifetime' picture doesn't end up being 'the one that got away'. Thankfully, all you have to do is master a handful of key techniques to get to the stage where you can guarantee 100 per cent success.

Light varies enormously, particularly in terms of contrast, intensity and colour, and to be a successful photographer you always need to take this into account.

Contrast

One of the key ways that light varies is in terms of contrast – that is, the range of tones between the lightest and darkest parts of the scene. Sometimes this range is very large, featuring intense, rich blacks, and bleached, white highlights. At other times the range is more limited, representing subtle shades of grey, rather than extremes.

The principal factor in whether the contrast in the scene is high or low is the light. Intense light from a point source produces hard, contrasty lighting; gentle light from a diffused source produces soft, shadow-less lighting. Neither is better than the other, both – and all the steps

Although our eyes compensate for it, the light you get from a normal household lamp is actually a strong orange. The white balance control on a digital camera will often remove it, but you can make sure it does not – since the results are sometimes attractive, as in this case – by choosing the 'daylight' or '5500k' setting.

THE KELVIN SCALE

2000k
The light from candles and fires in general is extremely orange, and registers on the film as a very strong cast.

3000–3200k
The light from household tungsten lamps is very warm, producing a strong orange colouring.

3500–4000k
Sunrise and sunset are amongst the most photogenic of times for taking pictures.

4200–4800k
Early morning and late afternoon sun often has an attractive warm quality that records beautifully without being too orange.

5500k
Noon sunlight is neutral in colour, which produces pictures without any colour cast at all. The same applies to electronic flash.

6000–6500k
Hazy skies tend to have more blue in them, and can give your pictures a slightly sombre feel.

7000k
On heavily overcast days the light can be a very strong blue, giving your photographs an extremely cold feel.

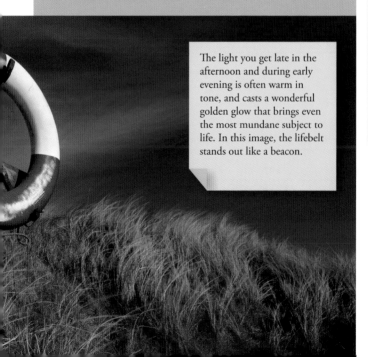

The light you get late in the afternoon and during early evening is often warm in tone, and casts a wonderful golden glow that brings even the most mundane subject to life. In this image, the lifebelt stands out like a beacon.

in-between – have their place in photography. Indeed, it is this gradation of light which offers such freedom of expression.

Intensity

Taking pictures is easier when there is plenty of light. You are free to choose whatever combination of shutter speed and aperture you like without having to worry about camera-shake or subject movement. However, do not for a minute confuse quantity with quality. The blinding light you find outdoors at noon on a sunny day may be intense, but it is far from ideal for most kinds of photography. Better results are generally achieved when the light is softer. A golden rule of photography is that the quality of light is always more important than the quantity.

Colour Temperature

We generally think of light as being neutral or white, but in fact it can vary considerably in colour – you need only think about the orange of a sunrise or the blue in the sky just before night sets in. The colour of light is measured in what are known as Kelvins (k), and the range of possible light colours – which is extensive – is shown in the Kelvin scale in the panel on page 69.

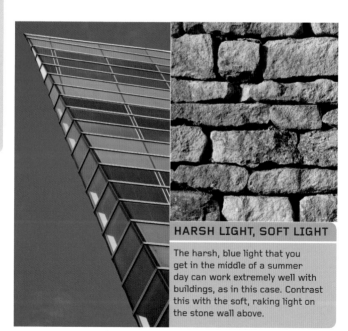

HARSH LIGHT, SOFT LIGHT

The harsh, blue light that you get in the middle of a summer day can work extremely well with buildings, as in this case. Contrast this with the soft, raking light on the stone wall above.

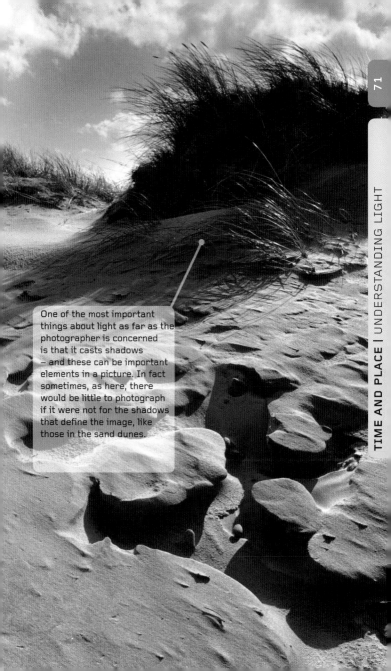

TIME AND PLACE | UNDERSTANDING LIGHT

One of the most important things about light as far as the photographer is concerned is that it casts shadows – and these can be important elements in a picture. In fact sometimes, as here, there would be little to photograph if it were not for the shadows that define the image, like those in the sand dunes.

The direction from which light is coming has a significant impact on the overall look and feel of a picture. Think about where the light is in relation to you when you take the shot and your pictures will always benefit.

Side Lighting

Turn through 90 degrees when preparing to take your picture, and you have the sun coming in from the side. Doing this immediately opens up an exciting door to creativity: where once stood flat, featureless scenes, there are now highlights and shadows. You can see that objects in the foreground are independent of the background because shadows falling to the side emphasize distance.

Top Lighting

Of all the kinds of lighting available to the photographer, top lighting is probably the least satisfactory. You get it around noon on a sunny day in summer, when the sun is at its highest. Shadows are short, downward-pointing, and rather dense. It is best avoided, particularly for portraiture, when you can end up with dark areas under the eyes, nose and chin.

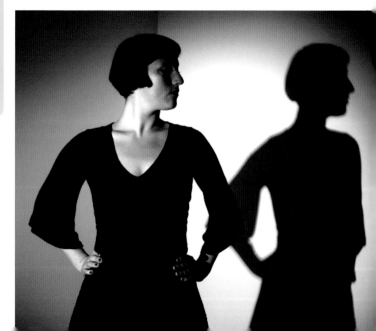

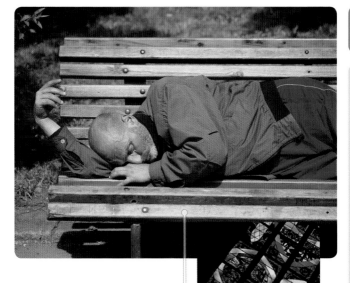

SIDE LIGHTING

Side lighting is perfect for character portraits – and throws evocative shadows into the bargain.

Top lighting is strong and harsh, but can work for certain kinds of subjects – such as this man sleeping on a park bench in Bulgaria.

Oblique light shining through stain glass windows is often very muted, but can show the rich colours off to their best effect. Avoid direct, bright, sunlight when shooting such subjects.

Successful outdoor photography depends on an understanding of light, and how it changes through the day. This is especially important in landscape photography.

How Light Changes

The light changes in three ways: its direction; its quality; and its colour. On sunny days, the changing direction of the light is most obvious. Early in the morning or late in the day the sun is low in the sky and the light 'skims' across the landscape highlighting textures and forms. In the middle of the day, the sun is higher in the sky. The light is quite harsh and uninteresting, and few landscape photographers take pictures at this time. The light quality – its 'hardness' or 'softness' – may vary considerably, as well. This is most obvious on overcast days, when the light comes from the whole of the sky and not from any one particular direction.

Light Tips

Overcast days are much better for outdoor portraits because there are no harsh shadows. There may still be a directional quality to the light which you can use to bring out shape and form – look for partially-shaded areas under trees, for example, or in doorways or by walls. Light changes colour during the day because of the position of the sun and the properties of the atmosphere.

COLOUR TEMPERATURE AND TIME OF DAY

The colour of light can be measured as its 'colour temperature'. The units for this are 'degrees Kelvin', or 'K'.

Dawn before sunrise: 10,000 degrees K A characteristic strong blue colour.

Dawn: 2,000–2,500 degrees K The first appearance of the sun on the horizon produces very warm colours.

Early sun: 3,000–4,000 degrees K As the sun climbs higher in the sky, the colour temperature rises.

Midday: 5,500 degrees K Overhead sun at noon produces neutral colours.

Overcast: 7,500 degrees K Overcast conditions increase the colour temperature markedly.

Shade: 10,000 degrees K The colour temperature of shade on a sunny day is extremely high.

Afternoon sun: 3,000–4,000 degrees K The light becomes warmer and 'redder'.

Sunset: 2,000–2,500 degrees K When the sun is on the horizon, the light is at its 'reddest'.

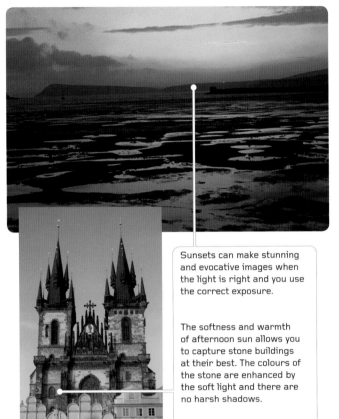

Sunsets can make stunning and evocative images when the light is right and you use the correct exposure.

The softness and warmth of afternoon sun allows you to capture stone buildings at their best. The colours of the stone are enhanced by the soft light and there are no harsh shadows.

Light changes throughout the day, but it changes through the seasons, too. In winter the light on sunny days will be warmer in tone. Springtime brings longer days and a higher sun, but the air is still quite cool and the light has a clarity and a freshness. Summer can yield wonderful photographs at the beginning and the end of the day. Autumn brings a return to low temperatures and crisp, clear air.

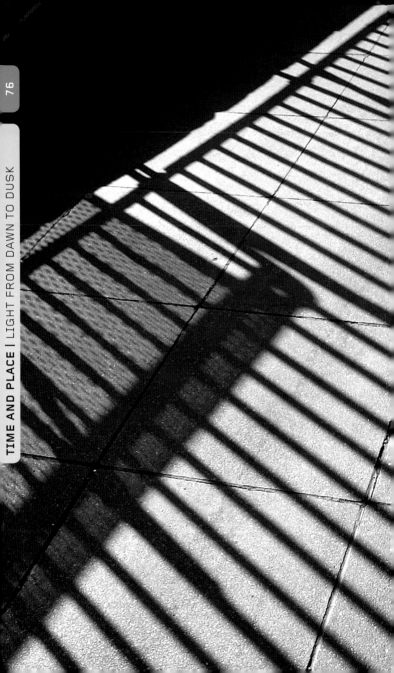

Blue light is scattered more strongly than red light, and when the sun is lower in the sky it passes through a thicker layer of atmosphere. The blue light is scattered more, which is why the light appears redder at these times of day. Before dawn and after sunset, however, the light colour changes dramatically, becoming much bluer. Changes in the colour of the light are far less noticeable on overcast days, when the light has a colder tone all through the day. For this reason, many landscape and outdoor portrait photographers use colour correction filters to 'warm up' the colour in their photographs.

Getting closer to the light makes it easier to maintain a shutter speed that avoids camera-shake – and if you include the light source itself it becomes easier still.

Diminishing Light

When light levels begin to drop, most photographers heed the camera's shake alert and switch over to flash, thus avoiding the risk of camera-shake. However, this can be a disheartening experience. The problem with using flash is that it can all too easily obliterate the mood that made you want to take the picture in the first place. This dilemma can arise in any situation, but happily there are ways you can continue using the available light and not have to resort to flash.

Support the Camera

Supporting the camera in some way allows the shutter speed to drop to levels which otherwise might cause camera-shake. Normally it is not advisable to hand-hold the camera below 1/60sec for a standard zoom or 1/250sec for a telephoto zoom. However, if you brace yourself carefully you may be able to get away with 1/15sec and 1/60sec respectively. You will need to hold the camera tightly, though, to avoid camera-shake. Tuck your elbows in close to your body and then breathe out before squeezing the shutter release button smoothly. A better option is to look around and see if you can find some way of supporting the camera, such as a wall, table or other flat surface. Whenever possible, though, you should use a tripod, in which case you can set whatever shutter speed you like without fear of lack of sharpness caused by camera-shake.

Increasing the ISO setting, so that the sensor is more sensitive to light, will enable you to keep taking pictures when light levels drop. If you generally shoot at ISO100 you could go to ISO200 or even ISO400 – in most cases without a significant drop off in quality. But once you go beyond that – to ISO800, ISO 1600 or even ISO 3200 film, which are two, three and four times as sensitive respectively – you will end up with images that are not as sharp, not as rich in colour and not as detailed.

Stage lights can be extremely atmospheric, and using flash here would have completely ruined the mood of the shot. Increasing the ISO rating to 800 results in an image that is a little soft but more than acceptable.

Taking pictures at night is easy – and the results can be spectacular. All you need is a camera which can give exposures measured in seconds and a tripod to prevent camera-shake.

Photography After Dark

The best time to snap your 'night' shots is at dusk, just after the sun has set, when there is still some colour in the sky. Getting a balanced exposure is also easier at twilight. If you wait until it is totally dark, the contrast range is too great to be captured successfully – and there is a constant risk of over-exposure if you leave the camera to its own devices. You will also need to watch the white balance. Part of the charm of night shots is the vibrancy and excitement of the many different coloured lights. But auto WB systems can easily 'compensate' for the variety of sources, leaving you with images that are rather bland. Most of the time you will find it best to set the white balance to daylight, so that floodlit buildings have the warm, orange glow we expect them to have.

With their blaze of bright lights, fairgrounds are great places to visit with night photography in mind. Shooting an hour before dusk means the sky is a rich blue rather than a dense black.

Neon signs are a common sight in most big cities. Take care with your exposure, though, as dark surrounding areas can cause the lights to burn out.

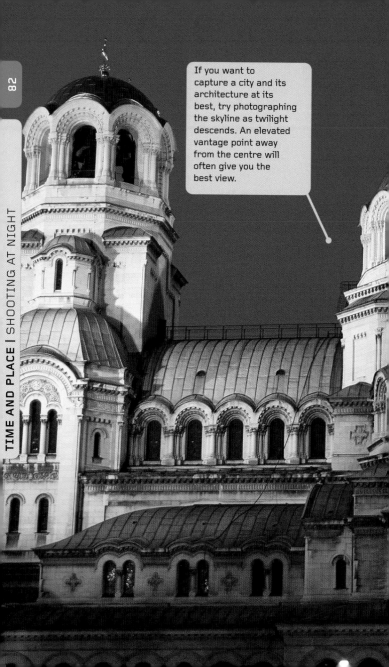

If you want to capture a city and its architecture at its best, try photographing the skyline as twilight descends. An elevated vantage point away from the centre will often give you the best view.

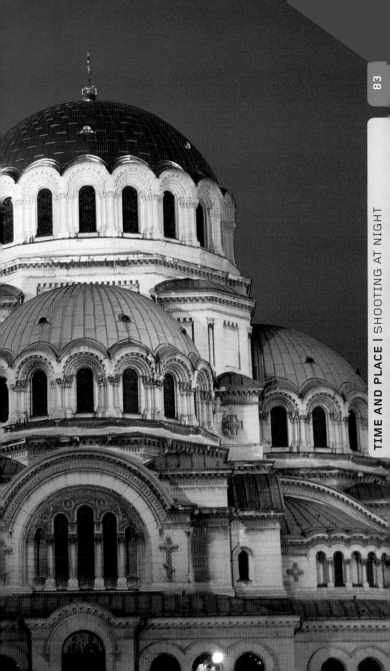

Because colour is all around us, we often take it for granted. That is a real pity, because one of the easiest ways of giving your pictures more impact is by improving your use of colour.

The Value of Colour

Colour is one of the most valuable compositional tools you have at your disposal, allowing you not only to determine the overall mood of the picture, but also where to place the emphasis.

Yellow, orange and red work well together, as do green, blue and purple. Soothing, relaxing scenes made up of harmonious colours crop up everywhere. It is just a matter of looking out for them.

Contrasting colours give a much more dynamic feel compared to harmonious colours and create more visual tension. Put red and blue together, for instance, or green and pink, and you have a dramatic contrast that is guaranteed to be eye-catching.

Individual Colours

Psychologists have carried out an enormous amount of research into the emotional effects of colour, and nowadays they have a clear idea of how people react to each of the tones.

The three primary colours – red, blue and green – are particularly

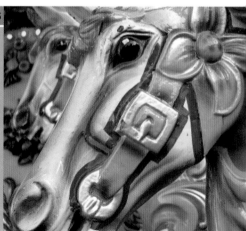

CHOOSE COLOURS

Looking for the secret of success in photography? Simply choose subjects that have strong, bright colours and crop in close. The more colours the better – in most cases – and the stronger and more vibrant they are, the greater the chances of a positive result.

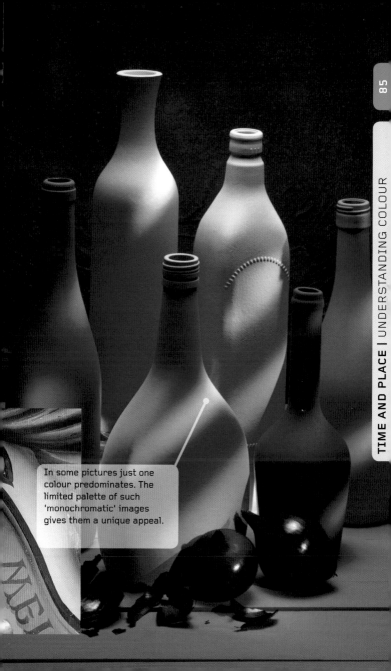

In some pictures just one colour predominates. The limited palette of such 'monochromatic' images gives them a unique appeal.

powerful, and add energy and impact to any image. Red is the strongest colour of all and can dominate a picture even if it occupies only a small area. As well as grabbing attention in their own right, blue and green also make excellent background colours, as they are said to 'recede'. For the best results, shoot in strong, bright light.

One important distinction to be aware of is between 'warm' and 'cool' colours – because these go a long way towards establishing the overall mood of a shot. 'Warm' colours – yellow, orange and red – give a positive, up-beat feel to a photograph, while 'cool' colours – blue, cyan and green – have a more tranquil effect in images.

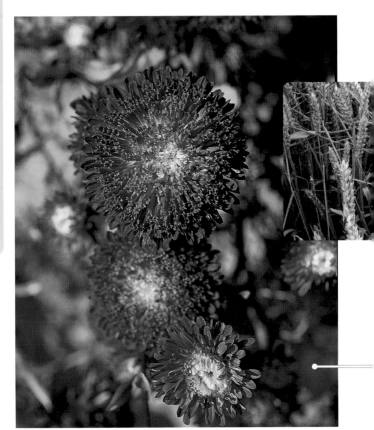

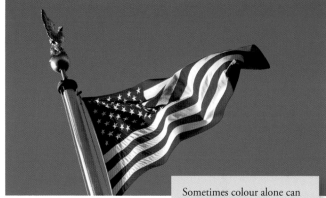

Sometimes colour alone can make even the very simplest images shine out like a beacon. The bold, brightly coloured stars and stripes of the American flag contrast strongly with a perfect blue sky in the image above.

The splash of red made by the lone poppy is what makes this photograph so successful, although the image is also full of interesting textural contrasts.

In this photograph of some purple flowers, the strong colours are accentuated by the yellow blobs at the centres of the blooms combined with the hazy perspective of the knocked-out background to the image as a whole.

Painters have a distinct advantage over photographers when it comes to composing a picture. Their canvas is empty, and they can arrange the elements in a scene more or less as they wish – even excluding features, if they feel that this is necessary.

Selecting the Scene

Unfortunately, you don't have the same freedom. Your canvas is already full, so in order to create a successful composition you first have to decide which part of the scene you want to capture, then arrange the elements contained in it so that they form a visually pleasing whole.

A good photographic composition should be like a good story – with a beginning to grab your attention, a middle to hold that attention, and an end to bring your journey to a satisfying conclusion.

To help you achieve this effectively, there are many different tools at your

> ### MAKING CHOICES
>
> You are exclusively in control of your compositions – so make them interesting. Wander into the street and see what you find. Keep your eyes and mind open.

disposal. Lenses allow you to control how much or how little is included in a shot. Choice of viewpoint and use of perspective affect how your subject appears. The quality of light can also be used creatively because it influences how well texture, shape, tone, colour and form are defined in a scene.

Ultimately, however, good composition is about looking and seeing. It's about making visual

> Think carefully how you arrange the various elements of the picture before you press the shutter. In the image to the left, the curves of the building have been placed so that they lead the eye of the viewer off into the distance.

FRAMING THE SUBJECT CREATES A SENSE OF DEPTH.

How to Hold a Camera

How you hold your camera is vitally important when composing a picture. In the case of digital compacts which have a 'live' screen on the back (LCD) rather than a viewfinder, the technique is to hold the camera level with both hands out with elbows slightly bent, so that you have a clear view of the screen as you take the picture (see below). In the case of SLRs that give direct viewing through-the-lens, what you see through the viewfinder is pretty much what you will get in the final picture, so hold it close to your face (see above).

You can create a dynamic composition by placing the subject across the diagonal of the frame. In this case, the angle of the white line in the image creates a feeling of immediacy – more so than if the white line was shot directly head on.

decisions and allowing your own vision to guide you towards those decisions, so that the pictures you make are unique to your own way of seeing but nevertheless appealing to others at the same time.

There is no substitute for experience and you will find that over a period of time you begin making instinctive judgements about the best way to frame your shot. However, when you are starting out, it is a good idea to adopt a few tried and tested techniques, from dividing the frame to ensuring you have a focal point and many more.

The following pages explain the principles of composition in some detail. Remember, you can often take a good picture by making do with what is in front of you, but to make that picture great it must be properly composed.

Making use of naturally occurring shapes gives the image structure and form. Simple shapes such as eggs can produce a striking image when they are gathered together in a round bowl, as in the photograph below.

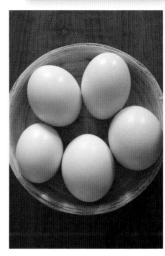

FRAMING FOR EFFECT

Framing the subject creates a sense of depth. In this case, an already stately, grandiose building is invested with even more visual power by the deliberate positioning of a dark framing archway in the foreground of the shot.

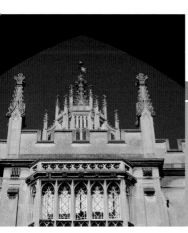

The way you divide up the picture area of your photograph can have a strong influence on its impact and how it is 'read' by the viewer — even though they won't be aware of this at the time of viewing.

Trying Alternative Frames

For example, if you place the horizon low in the frame (see below left), emphasis is placed on the sky and a general feeling of wide open space is created. This technique works well when the sky is interesting and demands attention – such as a mackerel sky at dawn or dusk. Alternatively, by placing the horizon high in the frame (see below right), the foreground of the scene is emphasized and features close to the camera are given priority so that you can make the most of lines to lead the eye into the scene, or foreground objects to add a sense of perspective and scale. Placing the horizon across the centre of the frame so the image is split into two is often frowned upon.

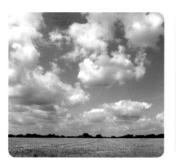
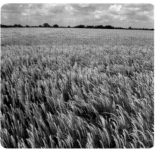

The most important thing with landscape photography is not to include too much. Faced with a great expanse of gorgeous countryside, you may be tempted to just start snapping away. However, when there is too much in the frame you can lose impact. Start, then, by deciding what it is about the scene that attracts you. Maybe the light on the hills catches your eye or the pattern created by a dry stone wall?

FRAMING FOR THE BEST EFFECT

The three pictures on these pages demonstrate some of the options you have when photographing a landscape.

- Placing the horizon in the middle of the frame would give a balanced composition, but the result would not be very exciting.
- Placing the horizon lower, in order to emphasize the sky, produces more drama.
- Limiting the amount of sky included focuses attention more on the foreground, but lends the image a somewhat odd quality.
- Probably the most successful approach is demonstrated in the main image below, where a clear focal point – the tree on the horizon – balances well with the dramatic sky and the more prosaic foreground.

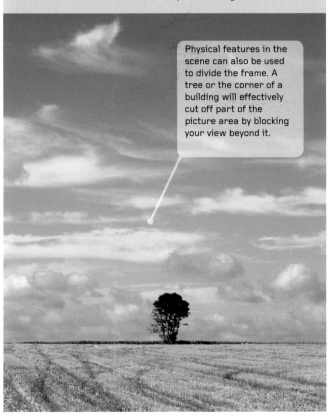

Physical features in the scene can also be used to divide the frame. A tree or the corner of a building will effectively cut off part of the picture area by blocking your view beyond it.

Most pictures will have or should have a main point of interest. This is known as the focal point, and it serves two important purposes: firstly, it is the element in the composition to which the viewer's eye is naturally drawn and finally settles upon having gone on a journey around the picture; secondly, it adds a sense of depth and scale to the composition.

Your Ideal Focal Point

If you photograph a landscape scene and there is a tractor chugging away in the distance, that tractor automatically becomes the focal point because our eye is naturally drawn towards it. The same applies if you photograph a seascape featuring a lighthouse on the horizon, a field with a barn in its middle, or a cliff face with a climber suspended halfway up it.

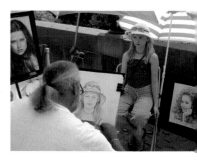

The focal point does not have to be big in the picture to do its job, providing it is clearly visible. Colour can help here. A splash of bright colour will always attract attention in an image – especially red.

The girl, the drawing of her, the pictures scattered around the main subject – this image has lots of competing points of interest which prevent the viewer's eye settling successfully in any one place.

Placing the important part of the picture in the centre makes for a clear, strong focal point – but make sure it is big enough to have plenty of impact.

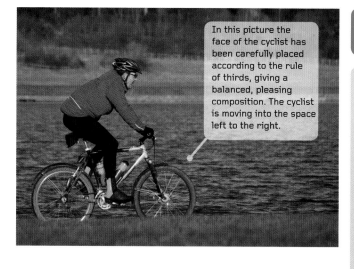

In this picture the face of the cyclist has been carefully placed according to the rule of thirds, giving a balanced, pleasing composition. The cyclist is moving into the space left to the right.

RULE OF THIRDS

The most common compositional 'device' is the rule of thirds. It involves dividing the picture area into a grid of nine equally-sized segments using imaginary horizontal and vertical lines (see right). The idea is that you then place the focal point on one of the four intersection points created by those lines so that it is always a third in from the side of the image and a third up from the bottom or a third down from the top, balancing the image.

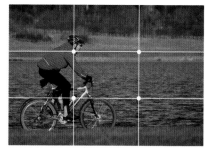

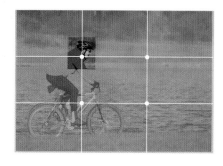

Where you stand to take your picture has a profound effect upon the result you achieve. As you become more experienced as a photographer, why not experiment with unusual points of view and shooting subjects from angles that are out of the ordinary?

Move For Better Angles

When you encounter an interesting subject, do not just fire away from where you are standing. Rarely will you stumble upon the best vantage point the minute you arrive at a location; so, make sure you spend a few minutes wandering around exploring it from every position – the chances are you will find a better one. The more time you spend looking for alternative viewpoints and different camera angles, the better your pictures will ultimately turn out to be. It is surprising how moving just a little to the right or the left, to the front or behind, can alter the perspective and significantly improve the picture. This is especially true with large subjects.

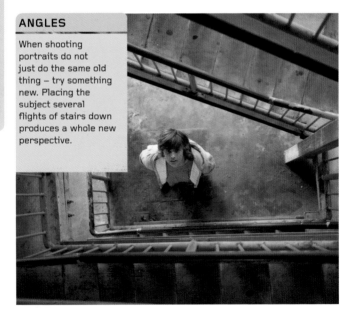

ANGLES

When shooting portraits do not just do the same old thing – try something new. Placing the subject several flights of stairs down produces a whole new perspective.

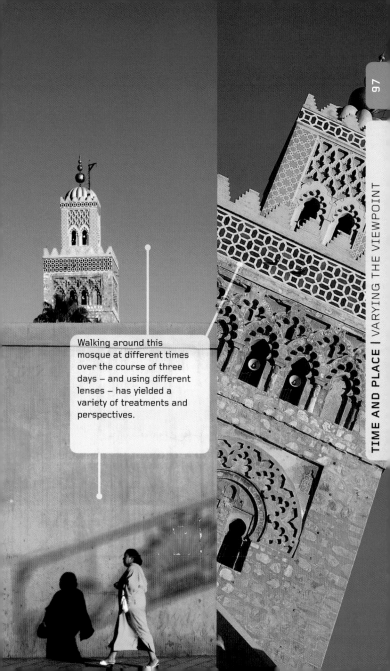

Walking around this mosque at different times over the course of three days – and using different lenses – has yielded a variety of treatments and perspectives.

There are various ways of creating a sense of depth in a picture. One of the quickest and easiest methods is to find or place something in the foreground that can 'frame' the main subject.

Finding a Frame

Many different things can be used as a frame. Look around you and you will discover that there is no shortage of natural props for creating depth. One of the most readily available, whether you are in the countryside or a town, is an overhanging tree. This can be used to frame a wide range of subjects – from landscapes to buildings to portraits. Simply place a branch so that it fills in the blank area of sky at the top of the frame, and your picture is immediately improved.

In towns and cities, you will find plenty of man-made frames to choose from. Arches are not only common, especially around ancient buildings such as cathedrals and stately homes, they often tend to

HOW TO CHEAT

When there is no suitable frame available, one option is to cheat. For example, when taking a picture of a new housing estate, where the trees are not yet mature, a crafty photographer who is thinking ahead might take along with them a branch they cut off from another tree before setting out. By holding it in front of the camera, they can position the frame exactly where they want it.

be very elegant. Gateways, and even ordinary doorways, can work equally well. In fact, with imagination, virtually any strong upright or horizontal shape can be used to form part of a frame for your image.

Placing the overhanging leaves of a palm tree in the corner of the picture makes all the difference. Cover that area with your hand and see how much weaker the composition is without it. This photograph was taken in Nice, in the south of France.

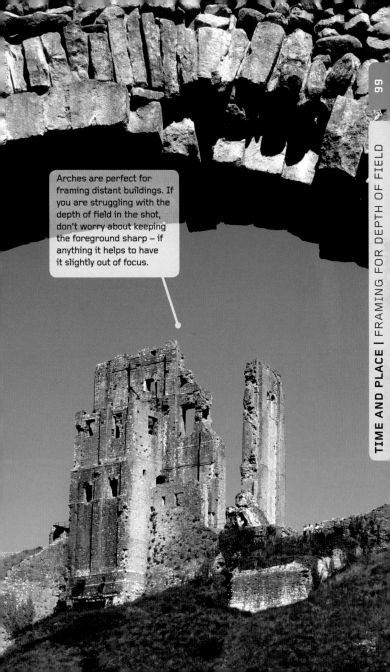

Arches are perfect for framing distant buildings. If you are struggling with the depth of field in the shot, don't worry about keeping the foreground sharp – if anything it helps to have it slightly out of focus.

When it comes to adding depth and dynamism to a picture, using lines cannot be beaten. As well as creating a strong sense of direction, they also carry the eye through the picture, so it takes in every element along the way.

Seeing Lines

If you keep your eyes peeled when you are out and about, you will start to see lines everywhere – roads, fences, rivers, lines of houses, rows of parked cars – and you will then be able to use them to improve the composition of your pictures.

Horizontal lines divide the frame, and produce a restful effect – because they echo the horizon. The eye normally travels from left to right, because that is the way in which we read type.

Thrusting upwards, vertical lines are a lot more active – so they can give a picture a strong sense of structure. Once again, you will find it easy to come up with subject matter. Most buildings feature strong verticals, along with natural structures such as trees and rock faces.

DIAGONALS

Diagonal lines are the most dynamic of all. They contrast strongly with any horizontal or vertical elements, and carry the eye through the whole scene. Lines that go from the bottom left to the top right deliver maximum power. While there are plenty of subjects that feature diagonals, one simple way of creating them is to angle the camera slightly. Do not be heavy-handed though – if you do it too much it can look like a mistake in the finished image.

Diagonals are always dynamic – and sometimes all you have to do to create them is to tip the camera to an angle of 45 degrees. This immediately adds drama and tension to the image.

Thanks to a low viewpoint and the use of a wide-angle lens, the lines in this landscape lead the eye directly to the castle in the distance.

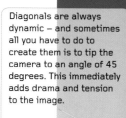

There are lots of different lines in this shot of rolling pins. However, because there are so many competing points of interest, the eye is unable to settle easily.

Shapes can be a useful compositional aid in photography, bringing structure and order to what might otherwise be a collection of random elements within a picture.

Being Aware of Shapes

We live in a world that is made up of shapes: the sun is circular; a family portrait often forms a triangle, with the parents in the middle and children to the sides; houses are square or rectangular.

We take these shapes for granted and are often not aware of them – but they can be used to make your photographic compositions stronger. By studying the various elements in the scene, and arranging them effectively, you can give your pictures more impact.

Shapes can be real or implied. A roof could be triangular; a face might be oval. Keep your eyes peeled for subjects that provide ready-made shapes and you will have a head start when it comes to composition. Implied shapes depend upon the way the elements in the pictures relate to each other. In portraiture, for instance, if your subject were to cup their face in their hands a triangle will be formed by their arms.

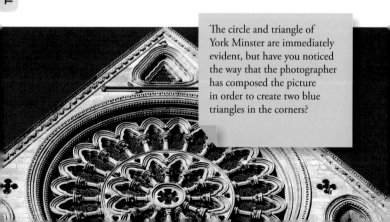

The circle and triangle of York Minster are immediately evident, but have you noticed the way that the photographer has composed the picture in order to create two blue triangles in the corners?

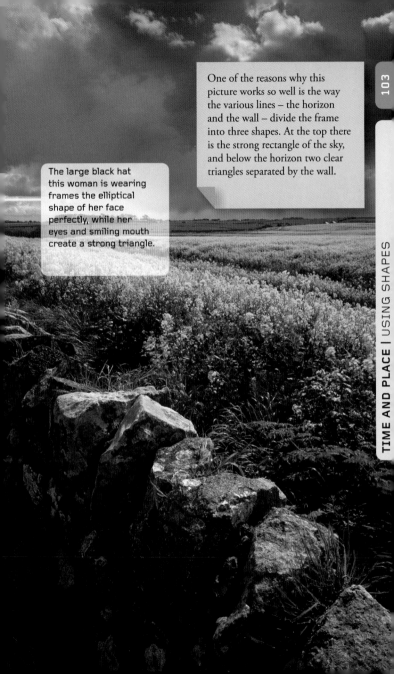

One of the reasons why this picture works so well is the way the various lines – the horizon and the wall – divide the frame into three shapes. At the top there is the strong rectangle of the sky, and below the horizon two clear triangles separated by the wall.

The large black hat this woman is wearing frames the elliptical shape of her face perfectly, while her eyes and smiling mouth create a strong triangle.

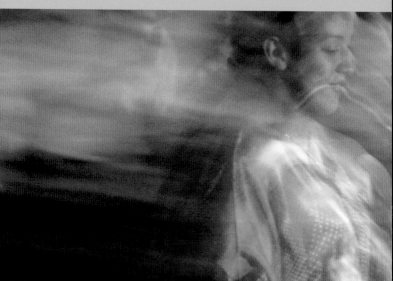

TECHNIQUES

Taking pictures is easy. But taking strong pictures that catch the eye and communicate powerfully is more difficult. You need to be able to create interesting compositions and use light effectively. Some photographers find this comes naturally. Others need to learn how. However, the good news is that mastery of a handful of techniques is all that is required to improve your image making.

Getting the right amount of light for a correct exposure is like filling a car up with fuel. Just as the car won't run properly if you don't put in enough of the right substance, an exposure will fail if there is too much or too little light – and if the light is the wrong kind, as well.

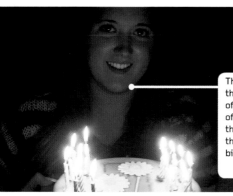

This image has just the right amount of light in it – all of it provided by the warm glow of the candles on the birthday cake.

Lens Aperture Settings and Shutter Speeds

Each time you take a picture you have to use both a lens aperture setting (f/stop) and a shutter speed to control the amount of light making the exposure; the aperture governs the quantity of light admitted and the shutter speed controls the length of time for which that light is admitted.

Basically, each time you set the lens aperture to the next biggest f/number in the scale – f/11 to f/16, say – you are halving the size of the aperture and therefore halving the amount of light admitted.

Conversely, if you set the lens aperture to the next smallest f/number in the scale, such as f/5.6 from f/8, you are doubling the size of the aperture and doubling the amount of light admitted.

The same principle applies with shutter speeds. Each time you double the shutter speed number – going from 1/60sec to 1/125sec, for example – you halve the length of time for which the shutter is opened. However, if you halve the shutter speed number – setting 1/15sec instead of 1/30sec – you will double the amount of time that the shutter remains open.

LIGHTING TIPS

Giving too much or too little exposure produces images that are too dark or too light. The images on these pages are four versions of the same picture, taken at different exposures. The version to the right demonstrates correct exposure, whereas the images around it show a variety of 'wrong' exposures.

The version of the image at top left was taken with -1 stop. Consequently, the image is under-exposed and too dark to be successful. At top right, the image was taken with -2 stops. The result is an even darker and more greatly under-exposed picture. Move to an exposure of +1 stop (bottom right) and now the image is becoming over-exposed – that is, containing too much light to be successful.

TECHNIQUES | UNDERSTANDING EXPOSURE

The units created by adjusting the aperture and shutter speed are referred to as 'stops'. One stop represents a doubling or halving of the exposure and can be achieved by adjusting the aperture, the shutter speed, or both. To understand this relationship more fully, imagine you are filling your car with fuel. The amount of fuel required (correct exposure) is provided by opening the valve in the hose (lens aperture) for a certain length of time (shutter speed). If the valve in the hose is small it needs to be kept open for much longer to fill the tank, whereas if the valve is large the tank will fill up very quickly. Either way, you will still end up with the same amount of fuel in the tank. Exactly the same principle applies to photography.

As well as helping you to achieve correct exposure, the shutter speed of your camera also controls the way that movement is recorded. Fast shutter speeds will freeze movement, but slow shutter speeds will record blur, which can be highly effective. You also need to consider camera-shake, which is caused if you try to take a handheld picture with a shutter speed that is too slow, causing blur to be created when you don't want it.

Beating Camera-shake

To combat camera-shake, the rule-of-thumb is to make sure that the shutter speed you use at least matches the focal length of the lens – so 1/60sec for 50mm, 1/250sec for 200mm and so on – though much depends on the steadiness of your hand as you take the picture.

Freezing Moving Subjects

If you want to freeze a moving subject, there are three important factors that must be considered: how fast your subject is moving; how far away it is from the camera; and the direction it is travelling in relation to the camera. If your

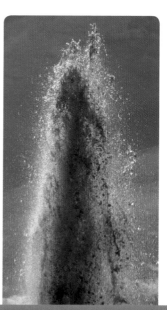

LONGER SHUTTER SPEEDS

For general picture taking using a standard zoom, go for a shutter speed around 1/125sec or 1/250sec (see left). When there is plenty of light you can make the most of your camera's fast shutter speeds – and capture lots of detail (see above).

SUBJECT	ACROSS PATH FULL FRAME	ACROSS PATH HALF FRAME	HEAD-ON
Jogger	1/250sec	1/125sec	1/60sec
Sprinter	1/500sec	1/250sec	1/125sec
Cyclist	1/500sec	1/250sec	1/125sec
Trotting horse	1/250sec	1/125sec	1/60sec
Galloping horse	1/1000sec	1/500sec	1/250sec
Tennis serve	1/1000sec	1/500sec	1/250sec
Car at 40mph	1/500sec	1/250sec	1/125sec
Car at 70mph	1/1000sec	1/500sec	1/250sec
Train	1/2000sec	1/1000sec	1/500sec

subject is coming head-on, for example, you can freeze it with a slower shutter speed than if it is moving across your path. Similarly, a faster shutter speed will be required to freeze a subject that fills the frame than if it only occupies a small part of the total picture area. A shutter speed of 1/1000 or 1/2000sec is fast enough to freeze most action subjects. Unfortunately, however, light levels won't always allow you to use such a high speed – even with your lens set to its maximum aperture – so you need to be aware of the minimum speeds required for certain subjects. Use the table above as a guide.

Other Options

Using a fast shutter speed is not always the best option, however, because by freezing all traces of movement you can lose the sense of drama and excitement. So don't be afraid to set a slow shutter speed and intentionally introduce some blur into your pictures.

When using a telephoto lens to photograph distant subjects – such as this candid, taken with a 400mm lens – you need a fast shutter speed to avoid the danger of camera-shake.

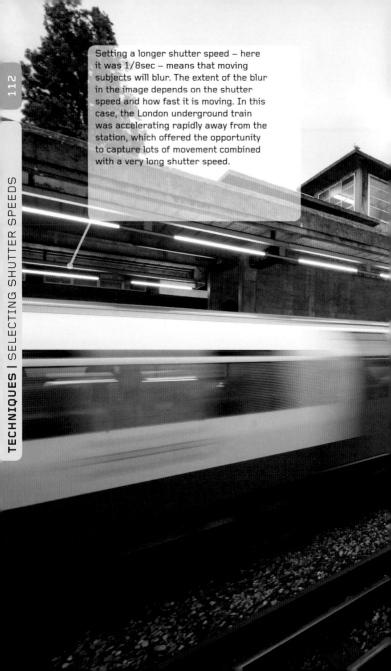

Setting a longer shutter speed – here it was 1/8sec – means that moving subjects will blur. The extent of the blur in the image depends on the shutter speed and how fast it is moving. In this case, the London underground train was accelerating rapidly away from the station, which offered the opportunity to capture lots of movement combined with a very long shutter speed.

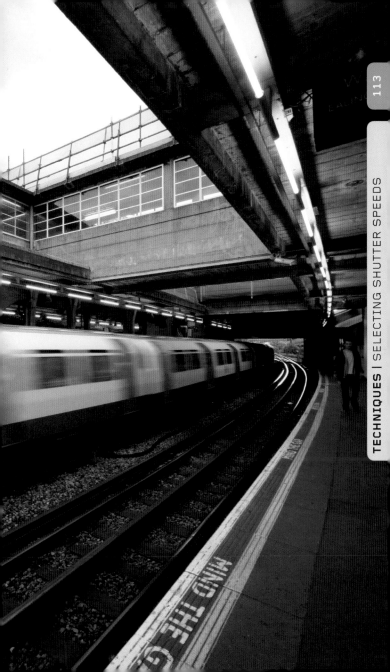

The aperture is essentially a hole in the lens that is formed by a series of metal blades, known as the 'diaphragm' or 'iris'. When you press the camera's shutter release button to take a picture, these blades close in on each other at the moment of exposure to form a hole through which whole light is able to pass. The precise size of this hole is denoted by the f/number you set the lens to – the bigger it is, the more light is admitted.

F/numbers

F/numbers follow a set sequence which is found on all lenses. A typical f/number, or aperture scale, on a standard zoom lens would be as follows: f/2.8; f/4; f/5.6; f/8; f/11; f/16; and f/22. The smaller the number, the larger the aperture, and vice versa.

Selecting an Aperture

Which aperture should you use? Well, that depends on what you are trying to achieve with your image. If you want to freeze a moving subject, then you need to set a wide

LIGHTING TIPS

The main thing to remember is that f/numbers are identical regardless of the focal length of the lens – f/8 is the same on a 50mm lens as on a 600mm lens.

aperture such as f/4 so that lots of light is admitted by the lens and your camera can select a fast shutter speed. Similarly, if you want to use a longer exposure, set a small aperture such as f/16 or f/22 so a slower shutter speed will be required.

Choosing as large an aperture as possible – in this case f/2.8 on a 70–300mm zoom – makes the hat stand out three-dimensionally.

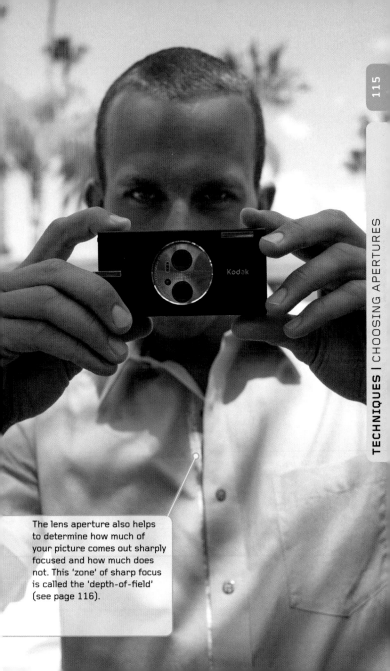

The lens aperture also helps
to determine how much of
your picture comes out sharply
focused and how much does
not. This 'zone' of sharp focus
is called the 'depth-of-field'
(see page 116).

Whenever you take a picture, an area extending in front of and behind the point which you actually focus the lens upon will also come out sharp in the image. This area is known as 'depth-of-field', and it is one of the most important variables in photography, because it allows you to control what will be in- and out-of-focus in your pictures.

There are three basic factors that determine how much – or how little – depth-of-field there will be in a photograph, as follows. Firstly, the smaller the lens aperture (the bigger the f/number), the greater the depth-of-field, and vice versa, for any given lens. Secondly, the shorter the focal length (the wider the lens), the greater the depth-of-field is at any given aperture. Thirdly, the further away the main point of focus is from the camera, the greater the depth-of-field will be for any given lens and aperture setting. To check depth-of-field you can use your camera's stop down preview facility (if it has one), which gives a fair indication of what will and will not be in focus in the photograph you are about to take.

+ DEPTH-OF-FIELD

If you want to achieve maximum depth-of-field so that everything is recorded in sharp focus from the immediate foreground to infinity – for example, when shooting landscapes – use a wide-angle lens such as 28mm or 24mm and set it to a small aperture.

– DEPTH-OF-FIELD

If you want minimal depth-of-field – which would result in little more than the main point you have focused on coming out sharp – use a telephoto lens in the range of say 200mm to 300mm set to a wide aperture such as f/4 or f/5.6.

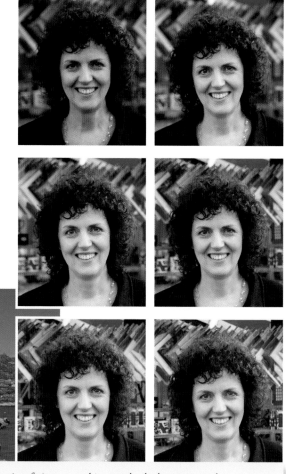

As the series of pictures on this page clearly demonstrates, large apertures (f/2.8, f/4, etc.) produce minimal depth-of-field (see the two top images), while small apertures (f/11, f/16, etc.) produce extensive depth-of-field (see the two bottom images). Average depth-of-field is reflected in the two central images.

Although the job of your camera's metering system is to produce correctly exposed images, it may do so using a range of different metering 'patterns'. These patterns vary the way in which light levels are measured by the camera in order to determine correct exposure, and some are more accurate than others.

Metering Patterns

There are a variety of different metering patterns for the keen photographer to choose from. These range from centre-weighted average – the standard metering pattern found in cameras – to 'intelligent' metering patterns known as 'Matrix' and 'Evaluative' respectively, which are the most sophisticated patterns available and make taking perfectly exposed pictures easier than ever. Partial/selective metering controls brightness and darkness in specific areas of an image; spot metering takes meter readings from a very small area of a scene; and multi-spot metering allows you to take a series of individual spot readings to find the very best exposure every time.

TAKING READINGS

Spot and partial metering are valuable when the main subject is either much lighter or much darker than the background. Going in close and taking a reading ensures that you expose the most important parts of the image to their best effect.

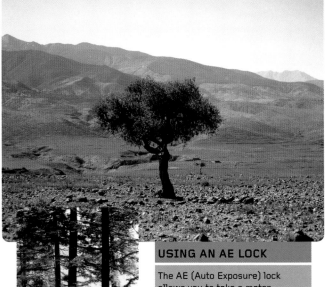

USING AN AE LOCK

The AE (Auto Exposure) lock allows you to take a meter reading and then hold it, even if the camera's position is changed. For example, when shooting landscapes you can tilt the camera down to exclude the sky from the viewfinder – which may cause underexposure – take a meter reading from the foreground, and then use the AE lock to hold the reading while you recompose the shot. This is a useful device when you want to take your time over a composition and get it absolutely right before pressing the shutter.

Traditional centre-weighted patterns place most emphasis, as their name suggests, on what is in the centre of the picture. They cope well with standard subjects, such as landscape, but can be fooled by images in which there is an uneven range of tones.

Light Subjects

The light meters built into cameras may be very sophisticated, but none are able to distinguish between bright lighting and subjects which are themselves intrinsically bright. In order to reproduce white subjects such as wedding dresses or snow as white, you must increase the exposure that is selected automatically by the camera.

Dark Subjects

The same applies to intrinsically dark subjects, although these are less common. The camera will assume that subjects are dark because of a lack of light and will then increase the exposure accordingly. You must reduce the exposure in order to render dark subjects as truly dark rather than the mid-grey tone that light meters are calibrated to reproduce.

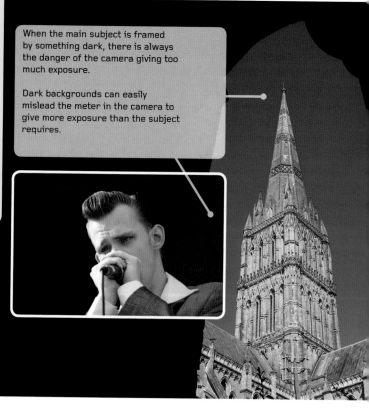

When the main subject is framed by something dark, there is always the danger of the camera giving too much exposure.

Dark backgrounds can easily mislead the meter in the camera to give more exposure than the subject requires.

INCREASING EXPOSURE

When part of the subject is in shade – such as the poppy and cross here – you may have to increase exposure to avoid the picture coming out too dark.

When there is a lot of sky in the picture, or the background is bright, you need to make sure the meter does not underexpose.

The way your camera sets the exposure of your image depends on the specific exposure mode that you are using as you set up the shot. Modern SLRs usually offer four main exposure modes, and although they all perform the same task of achieving correct exposure, they vary the level of control you have over the aperture and shutter speed set.

Program Mode

Some cameras have a program shift function which allows you to adjust the aperture/shutter speed combination chosen to suit a particular subject. This is an ideal mode for beginners.

Aperture Priority AE (Av Mode)

With this semi-automatic mode, you set the lens aperture (f/number) and the camera automatically selects a shutter speed to give correct exposure. The shutter speed is usually displayed in the viewfinder and on the top plate LCD, so that it is clear what setting the camera has selected.

Aperture priority is the most versatile exposure mode for general use. It gives you control over depth-of-field, because you choose which lens aperture you want to set.

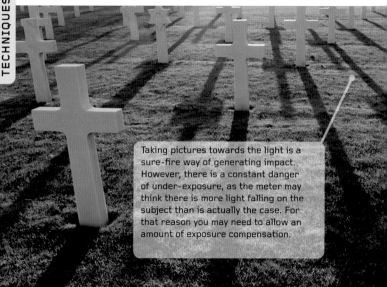

Taking pictures towards the light is a sure-fire way of generating impact. However, there is a constant danger of under-exposure, as the meter may think there is more light falling on the subject than is actually the case. For that reason you may need to allow an amount of exposure compensation.

Aperture priority mode allows you to choose the aperture, with the camera matching it to the correct shutter speed.

Shutter Priority AE (Tv Mode)

This mode is very similar to aperture priority but, as you have probably guessed, you select the shutter speed and the camera automatically sets the aperture required to give correct exposure. This is a handy mode for action and sports photography, in which the choice of shutter speed is more important than controlling depth-of-field.

Metered Manual

This is the simplest exposure mode of all. After taking a meter reading with your camera, you set both the aperture and shutter speed yourself, using a needle or some other indicator in the viewfinder to show when correct exposure has been achieved. Manual mode is ideal if you work with a handheld meter.

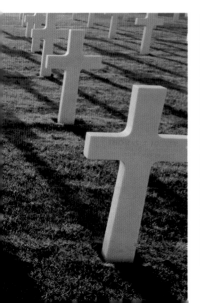

SHUTTER PRIORITY MODE

In shutter priority mode, you select the shutter speed – according to whether you want to freeze or blur – and the camera provides the corresponding aperture.

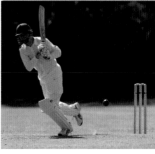

If you are a beginner to photography with limited experience and technical knowledge, anything that will help you to produce successful, appealing results every time has to be a good thing.

This is where subject-based exposure modes come in useful. These are basically program modes in which all the necessary camera functions such as aperture, shutter speed, autofocus mode, metering pattern, firing rate and flash mode are set automatically, but they are also biased towards a specific subject so that you can fire away without worrying if you have got the camera setting right.

If you set portrait mode the camera will automatically bias the exposure towards a wide aperture to minimize depth-of-field so that the background is thrown out of focus.

In action mode, a fast shutter speed is set to freeze your subject and the AF mode is set to 'servo' so that the lens will track your subject and keep sharp focus.

In landscape mode, a small aperture is selected to maximize depth-of-field so that the whole scene records in sharp focus.

To help you produce successful close-ups the camera automatically selects a small aperture to give increased depth-of-field – though it is still limited when shooting close-ups so you need to focus carefully.

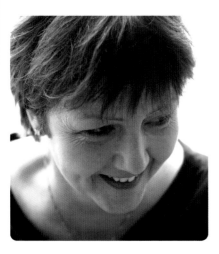

Portrait mode is optimized, as you might expect, for pictures of people. It sets just the right aperture for this kind of photography and, on most cameras, allows continuous shooting, so that you can capture any fleeting expressions your subject might make.

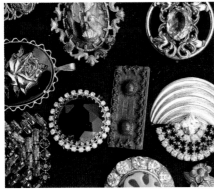

CLOSE-UP MODE

Close-up mode is also good for taking photographs of people, offering an alternative to portrait mode. In this mode it is easy to create strong depth-of-field effects, although this still requires careful focusing in order to work effectively.

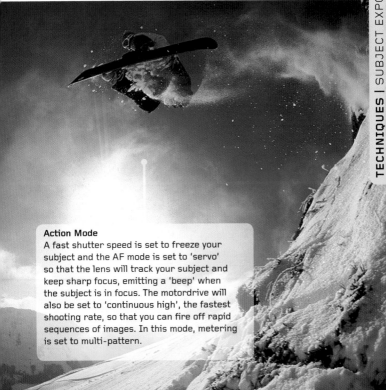

Action Mode
A fast shutter speed is set to freeze your subject and the AF mode is set to 'servo' so that the lens will track your subject and keep sharp focus, emitting a 'beep' when the subject is in focus. The motordrive will also be set to 'continuous high', the fastest shooting rate, so that you can fire off rapid sequences of images. In this mode, metering is set to multi-pattern.

DAY EXPOSURE

Portrait Mode

If you set this mode the camera will automatically bias the exposure towards a wide aperture (and high shutter speed) to that minimize depth-of-field so that the background is thrown out of focus. It also sets continuous shooting so that the camera keeps firing while the shutter button is depressed. In this mode, one-shot AF and metering is usually set to multi-pattern. This is one of the day exposure modes you are most likely to use when starting out.

Landscape Mode

A small aperture is selected to maximize depth-of-field so that the whole scene records in sharp focus; autofocusing is set to one shot and the motordrive to single shot. Metering is again set to multi-zone, as this is the most accurate system for achieving correct exposure in a range of lighting situations. Experiment with this mode before trying other more complicated ones.

NIGHT EXPOSURE

Night Portrait Mode

If you want to take a picture of someone outdoors in low light, night portrait mode combines a slow shutter speed to record the dark background of the shot with a burst of flash to light your subject.

Night Landscape Mode

In night landscape mode, the flash is turned off on the camera, a small aperture is selected to give increased depth-of-field and a long exposure is set to record low light. Focus is also set to 'one shot' and metering to 'evaluative'. You can achieve dramatic results with this mode.

When shooting a scenic view there is a lot to be said for using the landscape mode, which sets a small aperture to keep everything in sharp focus.

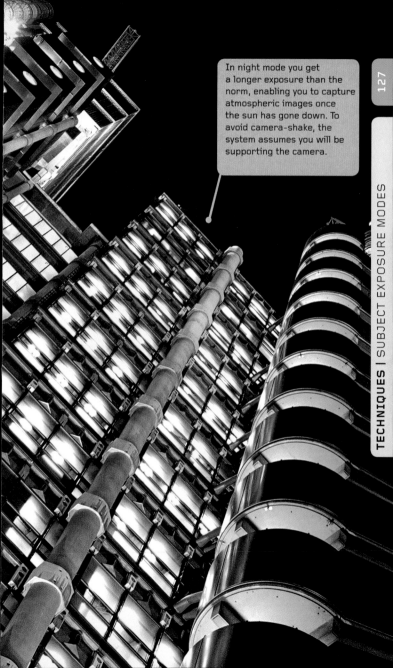

In night mode you get a longer exposure than the norm, enabling you to capture atmospheric images once the sun has gone down. To avoid camera-shake, the system assumes you will be supporting the camera.

TECHNIQUES | SUBJECT EXPOSURE MODES

The focusing systems used by modern cameras are incredibly sophisticated and make it easier than ever to achieve sharp focus in the poorest lighting situations – even total darkness. But which system is best? That depends on you and the subject you want to photograph.

Autofocusing

Autofocusing makes accurate focusing much easier and has been around now for almost two decades. Motors built into the lens respond to sensors in the camera and can achieve sharp focus in a fraction of a second – much faster than you could ever focus by eye.

Eye-control Focusing

A sophisticated alternative to autofocusing is eye-control focusing, in which the camera recognizes which part of the viewfinder you are looking at and then automatically activates focusing sensors in that area! This mode needs to be used with great care, as the lens may be fooled into focusing on the wrong area.

Wide-area and multi-point focusing systems are useful with off-centre subjects. In the portrait to the right, a standard, central autofocus system would have focused on the background instead of the person. One way to get around that problem is to use a focus lock.

HYPERFOCAL FOCUSING

To maximize depth-of-field, focus your lens on infinity then check the depth-of-field scale on the lens barrel to see what the nearest point of sharp focus will be at the aperture set. This is known as the 'hyperfocal distance'. By refocusing the lens on the hyperfocal distance, depth-of-field will extend from half the hyperfocal distance to infinity.

When your image features important
elements both in the foreground and the
background, you need to think carefully
about where you will focus. Here the
photographer decided that the writing on
the boat at the back was the most important
thing and locked focus on that.

SINGLE-SHOT VERSUS SERVO AF

In single-shot AF mode the lens will adjust and lock focus when
the shutter release is partially depressed. Then, once the lens locks
focus on your subject, you can take a picture. This makes it an
ideal mode for static subjects. If your subject is moving, however,
servo AF mode is preferable, as the lens will continually adjust
focus to keep your subject in sharp focus as you follow it through
the camera's viewfinder, until you are ready to take a picture.

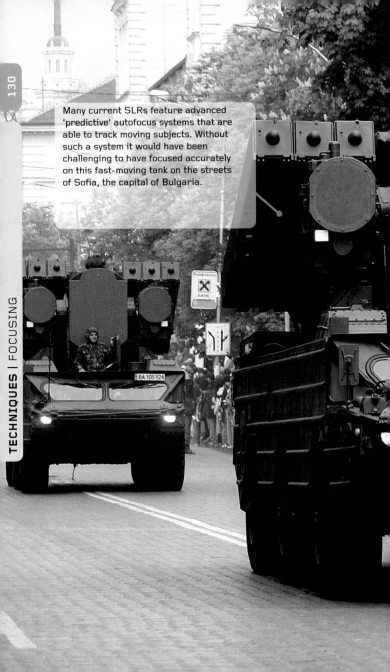

Many current SLRs feature advanced 'predictive' autofocus systems that are able to track moving subjects. Without such a system it would have been challenging to have focused accurately on this fast-moving tank on the streets of Sofia, the capital of Bulgaria.

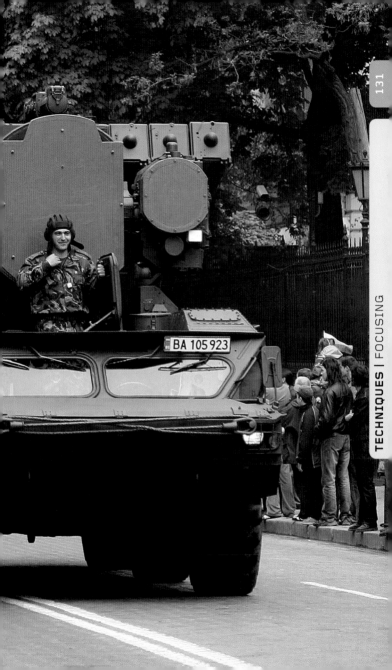

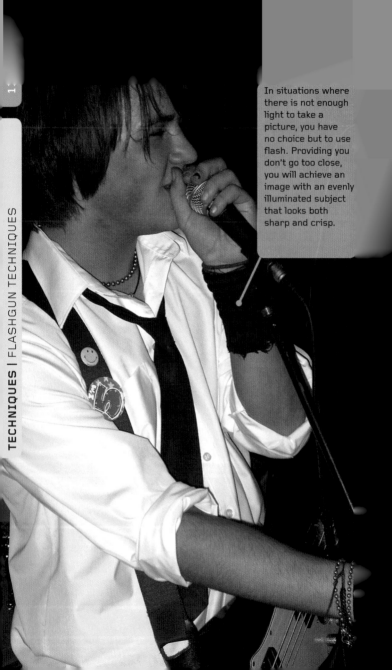

In situations where there is not enough light to take a picture, you have no choice but to use flash. Providing you don't go too close, you will achieve an image with an evenly illuminated subject that looks both sharp and crisp.

Modern flashguns are very sophisticated pieces of equipment, capable of producing perfect exposures time after time and allowing you to take pictures in situations which, without flash, photography would prove almost impossible.

Problems with Flash

Although flash can be a huge boon, it can also be fraught with problems if not used properly. The most common flash problem that you are likely to encounter is 'red eye', which is caused by flash bouncing off the blood vessels in your subject's eye so that they record bright red. It is most likely to occur if you use the flashgun on your camera's hotshoe – the obvious place to put it – though avoiding red eye is relatively straightforward.

Many flashguns have a red eye reduction mode which either fires a pre-flash or a series of weak flashes before the main flash exposure is made. The idea is that the pre-flash makes the pupils in your subject's eyes much smaller so that the risk of red eye is reduced. The problem with red eye reduction is that it can

RED EYE

Be prepared to break the rules. Red eye is normally considered a fault, but here it works beautifully. Using a special ring-flash produces a characteristic shadow all around the subject and dramatic soft lighting.

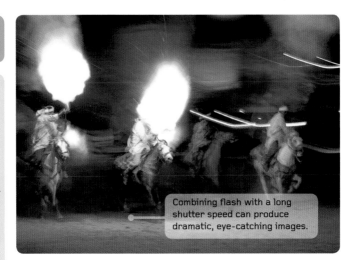

Combining flash with a long shutter speed can produce dramatic, eye-catching images.

confuse people into thinking the picture has been taken, so by the time the main flash fires they have already started moving away! If you find this to be the case, try the following:

• Ask your subject not to look straight into the lens.
• Use a flash diffuser to weaken the flash.
• Bounce the flash off a wall, ceiling or reflector.

• Take the flashgun off your camera's hotshoe and either hold it higher above the lens or off to one side.

The latter option above is perhaps the most effective, because it both prevents red eye and gives you more control over the direction of the light.

Direct, on-camera flash is very harsh and unflattering, casting ugly shadows on the background of the image to often disastrous effect.

Using more than one flashgun
If you want to create professional-quality lighting, several flashguns can all be used together at once. Some modern flash systems have a wireless option that allows you to synchronize several guns without connecting them all to the camera, though if your flash doesn't have this capability, accessories are available to achieve the same effect.

FLASH MODES

Here is a rundown of the most common flash modes and what they do:

Variable power output – Allows you to set the power output of the gun to 1/2, 1/4, 1/8, 1/16, etc., so that you can balance flash and ambient light for fill-in and slow-sync flash techniques.

Strobe mode – Some flashguns can be programmed to fire a rapid sequence of flash bursts automatically, allowing you to create multiple exposures of moving subjects – such as a golfer taking a swing.

Flash exposure compensation – Allows you to force the flashgun to give more or less light than it would if left to its own devices. This enables you to overcome exposure error when faced with a really light or dark subject.

TTL exposure metering – Ensures that correct exposure is achieved by linking the flash to the camera's integral metering system.

Slow-sync mode – Allows you to combine a burst of flash with a slow shutter speed (see box above right).

Using flash in conjunction with a long shutter speed – a technique known as 'slow-sync' – gives a ghostly effect. Foreground subjects in range of the flash are frozen, while things farther away are blurred by movement of the camera.

Using two flashguns, one behind the bride as well as one in front, highlights the transparency of the wedding veil. The clean white of the flash separates the young woman from the orange glow of the church lighting, emphasizing the main subject.

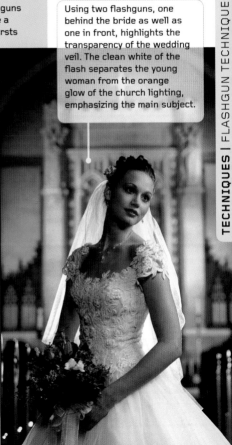

A single image can be extremely powerful – a moment frozen in time for posterity. But if one picture can paint a thousand words, what effect could a series or sequence of images have?

Look out for ways you can 'tell a story' by capturing several images one after the other. It could be something as simple as showing how an incident unfolded, such as the sets of pictures published here of the woman standing by the statue or the girl with the hula-hoop. None of the photographs on their own mean a great deal, but when you put all three together in each set, what is happening in the pictures becomes more interesting.

Subjects for Sequences

This approach can also be effective when shooting portraits. Instead of taking a single picture, you fire away and record a range of expressions. Put them all together and you show different aspects of your subject's character – something it is impossible to do in just a single shot.

Taking pictures in this way is also valuable for action of all kinds, from sport to everyday movement.

When you are photographing children playing, it is always worth taking a sequence of pictures, because they will tell the story far more effectively than a single shot.

A 'before', 'during' and 'after' series can be especially appealing.

How to Shoot Sequences

Shooting sequences could not be easier. You simply hold down the shutter release and a series of images is captured one after the other. The rate at which these can be recorded depends on a number of factors, including the resolution of the images and the speed at which the camera can store them on the memory card.

TIME-LAPSE PHOTOGRAPHY

Sequences do not have to be taken all at once in 'rapid fire' mode: they can be taken over a longer period or can even be used to document change over a longer time-scale, of say, days, weeks or even years. Here are some ideas:

- A bunch of tulips in a vase on a dresser lit by daylight – and photographed at the same time over successive days.
- Photographing the view from your window on the first day of every month will give a fascinating record of changing weather and light.
- Shooting a landscape from exactly the same spot across the four seasons is always interesting, especially if you choose very variable weather.

BUILDING CHARACTER INTO SEQUENCES

If you want to capture really interesting sequences of images, it is essential to keep your eyes peeled for spontaneous occurrences or action which tells a story of some kind. In the sequence on these pages, initially attracted by the statue, the photographer then noticed that while the woman in the picture talked animatedly on her mobile phone she was unconsciously mimicking the pose of the statue.

One of the latest digital SLR cameras on the market is capable of capturing ten high resolution images every second, but on most digital cameras the rate is much more modest – typically one or two shots every second. Also important is the shutter speed you are using – the faster it is, the more quickly you can shoot a sequence, so try to keep it up around 1/250sec. You should also avoid using flash, which usually takes a few seconds to recharge between shots, greatly limiting the speed at which you can shoot. Bear all these points in mind and you will be capturing great sequences of images in no time.

Once you have captured a sequence, go through the shots carefully. You may well have more than you need. Do not feel you have to use every one. Pick only those that are essential to the story.

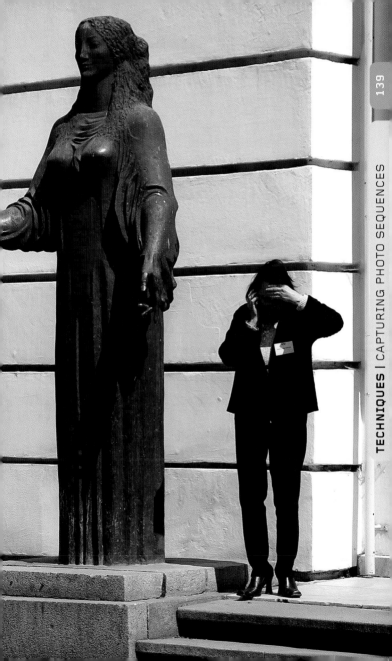

5

KIT

It is the enormous range of lenses and general accessories on the market that makes photography so creative and so enjoyable. Compact digital cameras now generally have a zoom lens with a decent angle from wide-angle to telephoto — making it possible to tackle most popular subjects successfully. Step up to SLR ownership and there are no limits to what can be achieved photographically.

It is always useful to have a cable or remote release for your camera and a mini table-top tripod. Both will fit into a modest-sized camera bag and will help improve your photography in any number of different situations.

Other Accessories

There are other items you should consider taking with you as well as a remote release and a mini-tripod. Modern cameras are increasingly dependent on battery power, especially digital models. Make sure you take a spare set of batteries, since those in high-draining devices like digital cameras will expire without very much warning. If you don't carry spare batteries, at least consider taking the camera's battery charger with you wherever you go. You will also need spare memory cards.

Do not forget to pack cleaning materials. A blower brush can remove dust from your lenses and viewfinder, while a soft cloth can be used to get rid of smears on lenses and LCD displays. Clean tissues are useful, too. Try a few different brands first, because unfortunately many types leave faint, oily residues on lenses which will adversely affect the quality of your images.

USING A NEUTRAL UV FILTER OVER THE LENS PROTECTS THE FRONT ELEMENT FROM DAMAGE.

Camera filters are still valuable accessories for certain kinds of work.

Reflectors are extremely useful accessories that allow you to control the light when shooting on location.

CAMERA BAGS

It is important to choose a suitable bag for carrying your photographic equipment. Proper photographic bags are more expensive than everyday bags, but they are much better in terms of organizing and protecting your equipment properly. While most photographic bags have adjustable internal dividers, for a good fit it is still a good idea to try them out in the shop with your own camera equipment.

Clockwise from top left:
Special cases are available in which filters can be stored; For the ultimate in protection, choose a hard case; Compact cameras are most easily stored in a simple pouch; Try a large holdall with plenty of sections to accommodate; Make sure you choose a bag that will protect your equipment against the elements.

You should use a tripod to prevent camera-shake in poor light or when taking photographs with long exposures. However, tripods have other less obvious but equally important uses. They keep the camera locked in a fixed position while you make careful adjustments to the composition and arrangement of objects in the frame, and they leave your hands free for adjusting props and so on.

Tripods

Tripods come with either ball-and-socket heads or pan-and-tilt heads. Those with ball-and-socket heads are the lighter and more compact of the two types, and very much quicker to use.

Monopods, Clamps and Bean Bags

There are alternatives to tripods which are less effective but which offer the advantages of being lighter and less awkward to set up and use. These include monopods (which are essentially one-legged tripods), clamps and bean bags. In particular, bean bags are often touted as the perfect portable support.

If you don't have a camera support with you, it is often possible to improvize. Night shots can be taken by resting the camera on a wall or table. You can also hold the camera against vertical surfaces such as walls.

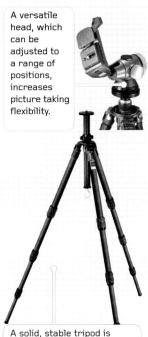

A versatile head, which can be adjusted to a range of positions, increases picture taking flexibility.

A solid, stable tripod is an essential purchase for anyone who is serious about taking quality pictures. Buy the best one you can afford and then upgrade it later on.

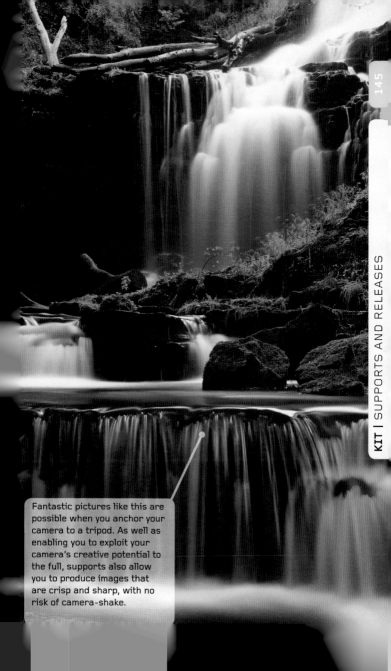

Fantastic pictures like this are possible when you anchor your camera to a tripod. As well as enabling you to exploit your camera's creative potential to the full, supports also allow you to produce images that are crisp and sharp, with no risk of camera-shake.

Digital cameras may be sold in 'body-only' form, but this option will normally only appeal to buyers who already have compatible lenses. Most buyers will choose a camera kit that includes both the body and a standard lens.

Choosing Lenses

Although most new cameras come with zoom lenses fitted these days, until fairly recently film cameras were supplied with only a fixed focal length lens. A typical standard lens has a focal length of 50mm or thereabouts, and is designed for general-purpose photography. Its angle of view closely matches that of the human eye, although some photographers feel that a 45mm lens is closer to the ideal. With a lens like this, the framing and perspective of shots looks natural, and this type has a large maximum aperture of f/1.8 or f/1.4. This makes it especially useful for shooting in low light or where you want shallow depth-of-field.

Standard Zoom Lenses

The zoom lenses that are a standard feature of most cameras sold today offer greater flexibility than the fixed focal length lenses of the past, covering a range of focal lengths from wide-angle all the way through to telephoto.

On a film camera, the usual standard zoom has a focal range of 28–90mm. On a digital SLR it is usually 18–55mm, which gives a comparable angle of view on this type of camera. You can use a 28–90mm film lens on a digital SLR, but the focal range is not ideal, because it does not provide proper wide-angle coverage on the smaller sensor.

USES FOR STANDARD LENSES

- Standard prime lenses are good for full-length portraits, because you stand far enough away to prevent distortion but not so far away that you run out of space when working in small rooms.
- The large maximum aperture of a standard prime lens will make it ideal for taking pictures at parties and celebrations where you don't want to use flash, which could disturb the subjects.

- A standard 28–90mm zoom lens (or its digital equivalent) is perfect for everyday photography, because it is compact and light and you will seldom need focal lengths outside this range.
- Standard zooms are perfect for travel photography as well, in situations where there is often little time to change lenses or viewpoints.

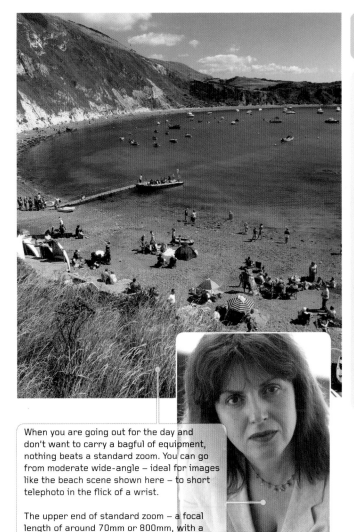

When you are going out for the day and don't want to carry a bagful of equipment, nothing beats a standard zoom. You can go from moderate wide-angle – ideal for images like the beach scene shown here – to short telephoto in the flick of a wrist.

The upper end of standard zoom – a focal length of around 70mm or 800mm, with a fast maximum aperture – is ideal for taking striking portraits of people.

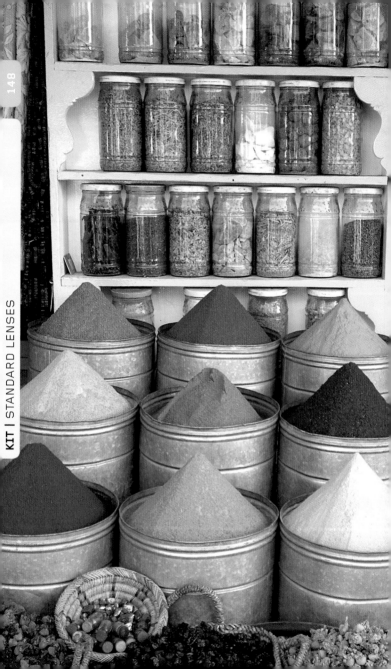

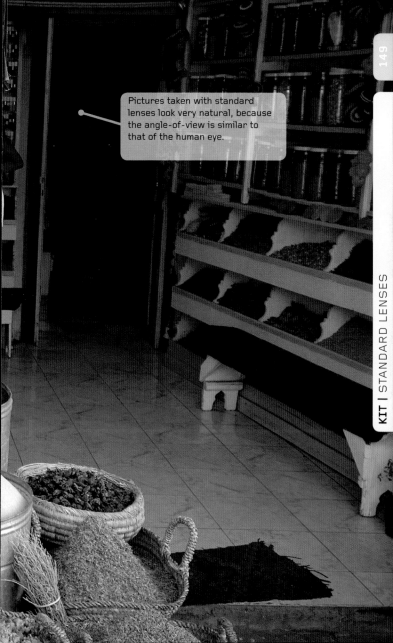

Pictures taken with standard lenses look very natural, because the angle-of-view is similar to that of the human eye.

A wide-angle lens enables you to get more into the frame of your image. At the same time it makes objects seem smaller and further away. A wide-angle lens has an obvious, practical value if you are trying to photograph a sweeping landscape or if you are taking pictures in confined spaces.

Wide-angle Versatility

The term 'wide-angle' covers a range of focal lengths. The standard zooms supplied with modern cameras usually have a minimum focal length of 28mm, which is probably as wide as you will usually need to go.

Just as there are super-wide fixed focal length lenses, so there are wide-angle zooms, which cover similar focal lengths, such as 16–40mm on a 35mm camera, or a 10–20mm lens on a digital SLR. These lenses are bulkier and more expensive than standard zooms.

In common with most specialist equipment, wide-angle lenses have both advantages and disadvantages and should be used sparingly and with care until you have some experience of their full capabilities.

Wide-angle lenses are great for architctural photography – especially when there is not much room to manoeuvre.

USES FOR WIDE-ANGLE LENSES

- Huge, sweeping landscapes can only be captured with a wide-angle lens.
- Used indoors, a wide-angle lens will make any room look larger than it really is and enables you to get more people into the shot.

- Landmarks are often hemmed in by other buildings, leaving you no room unless you have a wide-angle lens.
- Wide-angle lenses emphasize the big differences in size between close and distant objects.

One downside of wide-angle lenses is that they can introduce a lot of distortion into images. This is why they should always be used with care.

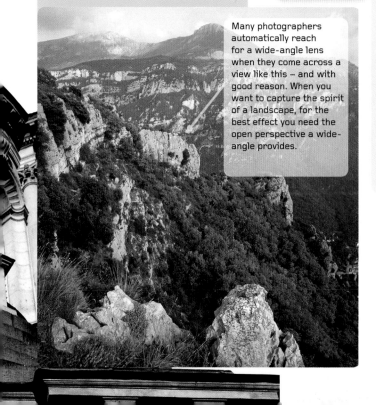

Many photographers automatically reach for a wide-angle lens when they come across a view like this – and with good reason. When you want to capture the spirit of a landscape, for the best effect you need the open perspective a wide-angle provides.

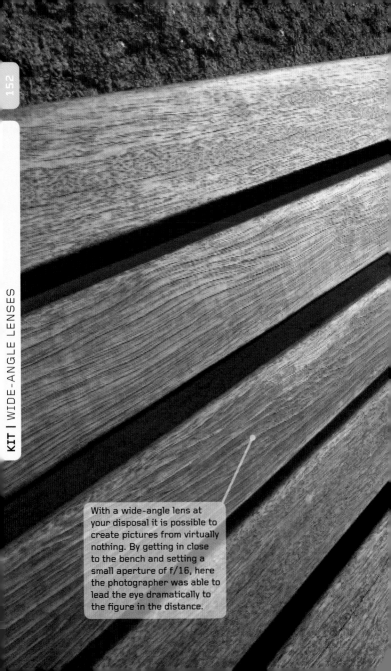

With a wide-angle lens at your disposal it is possible to create pictures from virtually nothing. By getting in close to the bench and setting a small aperture of f/16, here the photographer was able to lead the eye dramatically to the figure in the distance.

WIDE-ANGLE PERSPECTIVE

Wide-angle lenses have a profound effect on perspective. This is not because of their inherent optical properties – the explanation is, in fact, much simpler. Wide-angle lenses make objects appear smaller, with the result that you move closer to fill the frame. The fact of doing this exaggerates the difference in size between nearby objects and those further away. In turn, this produces the 'keystoning' effect which is often seen when tall buildings have been photographed from their base. However, this exaggeration of perspective can have creative uses, as well. The dramatic size differences between close and distant objects produce a strong feeling of three-dimensional depth and compositional 'movement' in images taken in this way.

Like telescopes or binoculars, telephoto lenses magnify distant objects. They are essential for wildlife photography and for taking good pictures of many sports. Telephoto lenses can also be useful for picking out details in landscapes, or for head-and-shoulders portrait shots.

Standard Telephoto Lenses

Like other lenses, telephotos are categorized according to their focal length. On a 35mm film camera, a 100mm lens would be a 'short' telephoto, a 200mm lens would be a 'medium' telephoto and a lens of 400mm or longer would be a 'long' telephoto. Due to the magnification factor from their smaller sensor sizes, digital SLRs make telephoto lenses 'longer'. Fitted to a digital SLR, a 200mm lens would have an equivalent focal length of around 320mm, and a 400mm lens would become a 640mm.

Professional photographers use fixed focal length, or 'prime', telephoto lenses. This is because they have wider maximum apertures which enable them to shoot in low light. This is essential for many sports, especially those held indoors under artificial lighting.

Telephoto Zoom Lenses

Telephoto zoom lenses are more versatile than standard zoom lenses but have smaller maximum apertures. However, their flexibility and lower cost make them better-suited to general purpose photography.

ADVANTAGES

- Wildlife photography is difficult or impossible without telephoto lenses, since animals and birds frighten easily if you get too close.

- Many sports are impossible to photograph successfully without a telephoto lens because spectator areas are a long way from the action.

- Telephoto lenses can produce striking landscape shots, since they enable you to pick out distant details and 'flatten' perspective.

- Portrait shots can be improved by throwing backgrounds out of focus. This requires shallow depth-of-field, a standard feature of telephoto lenses.

One of the great things about telephoto lenses is that they compress perspective – they make things that are actually some distance apart appear to be closer together. In this picture, the woman's eyes were actually some distance behind the boy in front.

DISADVANTAGES

Telephoto lenses appear to 'compress' perspective. Unlike wide-angles, they reproduce subjects and their backgrounds at their true relative sizes, or at least closer to them.
This effect will become obvious if you attempt to photograph a tree, for example, against a distant mountain. If you fill the frame with the tree in both cases, the wide-angle lens will make the mountain tiny, while the telephoto will make it look much larger.

Most 'kit' zooms (those supplied with the camera) have a maximum focal length of between 90 and 105mm, depending on the lens. This is not enough for sports and wildlife photography, and there may be other occasions in your photographic life when a longer lens is desirable or even essential.

Do bear in mind that the longer the focal length, the more difficult it will be to get steady shots. Small movements of the camera become magnified with long focal lengths and this causes two problems. Firstly, the subject will appear to bounce around the frame a lot more and it will be difficult to keep it centred. Secondly, camera-shake can cause blur at shutter speeds which would be 'safe' at normal focal lengths.

To find the minimum safe shutter speed, divide 1 by the focal length being used. With a 200mm lens, this gives a shutter speed of 1/200sec.

Some telephoto lenses have image-stabilization mechanisms which move elements within the lens to counteract any movement during the exposure. These can help you get sharp shots and shutter speeds two to four times slower than normal.

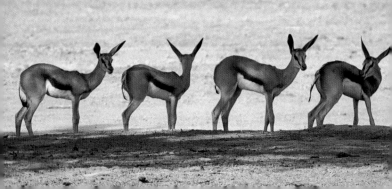

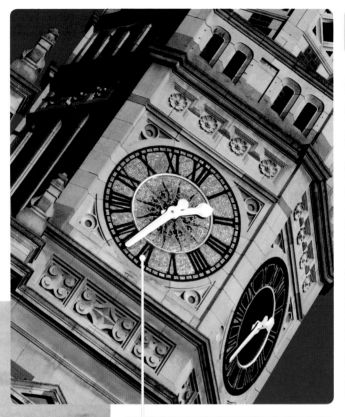

Telephoto lenses allow you to pick out details in the distance. This is especially valuable when you can't move any closer to your subject – such as this clock tower – or with subjects like sport and when taking candid portraits of people.

Telephoto lenses – and especially telephoto zoom lenses – are ideal for photographing wildlife, as shots can be taken from a distance so the subjects are not distracted.

At the extreme limits of optical design are ultra-wide and ultra-long lenses which can produce dramatic visual effects. However, these are also expensive and challenging to use.

Ultra-wide and Long Lenses

Ultra-wide-angle lenses can be difficult to use. To avoid dramatically converging verticals (keystoning), it is important to keep the camera level when shooting, and many architectural photographers will use a tripod and a spirit level as they set up their shot. Ultra-long telephotos pose different problems. These lenses are so heavy that they must nearly always be mounted on sturdy tripods instead of being hand-held.

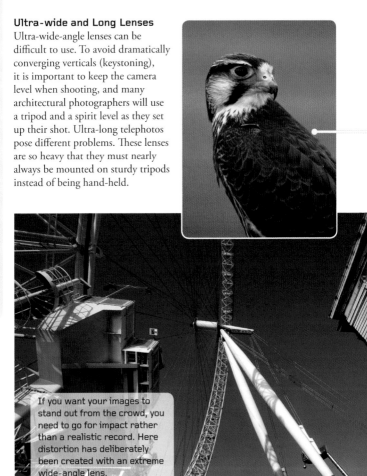

If you want your images to stand out from the crowd, you need to go for impact rather than a realistic record. Here distortion has deliberately been created with an extreme wide-angle lens.

Long telephoto lenses, with a focal length above 300mm, are essential for pulling in distant subjects such as this bird of prey. Care needs to be taken in using them, though, especially in order to avoid camera-shake.

Teleconverters

It is possible to increase the focal lengths of lenses with a 'teleconverter'. These are supplementary lenses which fit between the camera body and the lens and magnify the image by a fixed amount, such as 1.4x, 2x or 3x. They are a much cheaper alternative to long-range telephoto lenses so are good for beginners and those with limited budgets.

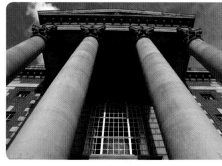

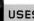

USES OF EXTREME LENSES

· Due to its scale, architectural photography can be quite a challenge. An ultra-wide-angle lens may be the only way to capture the subject in its entirety from the viewpoint available.

· It is very difficult to fully capture the interiors of buildings – whether they are small or large – without an ultra-wide-angle lens.

· In the case of sports that take place on a large pitch, such as baseball or soccer, you will need an ultra-telephoto lens to fill the frame with individual players.

KIT | EXTREME LENSES

Specialist lenses are available for very specific tasks that ordinary lenses cannot accomplish. There are a variety of different types available, offering applications that are useful to enthusiastic amateur photographers as well as seasoned professionals.

Soft-focus Lenses

Professional portrait photographers sometimes use soft-focus lenses with carefully designed optical properties that soften the details of complexions in a much subtler way than simply blurring them.

Macro Lenses

These are lenses which are designed to focus at very close ranges. The term 'macro' describes photography in which the image of the subject produced on the film (or the sensor) is the same size or larger than it is in real life. However, it is not just a question of making lenses focus more closely; photography at these distances requires a different optical design if the overall image quality is to remain high.

Shift Lenses

Shift, or 'tilt-shift', lenses are designed to tackle the problems of architectural photography. They are also known as 'perspective control' (PC) lenses. This is because they offer special movements which enable you to correct the 'converging verticals' or 'keystoning' effect you get when photographing tall buildings. With a conventional lens, the camera must be tilted upwards to get the building in the frame, and

this is what produces the undesirable perspective effect. With a shift lens, the camera is kept level, and the lens is shifted vertically upwards on its mount until the building is correctly positioned in the viewfinder. Shift lenses are expensive, specialized items. This is because the shift controls built into them must be very precisely engineered.

Specialist macro lenses are not cheap, but they are worth every penny. Using one it is possible to fill the frame with subjects that are extremely small – in the process producing pictures with lots of impact.

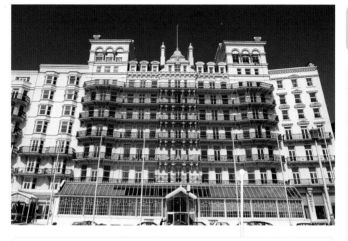

Using a specialist PC or shift lens, you can adjust the perspective so that the sides of a building stand upright rather than converge. In the picture above, a shift lens has not been used and the image has become badly distorted as a result. However, in the picture below the use of a shift lens has ensured the perspective is viewed as it would be naturally by the human eye.

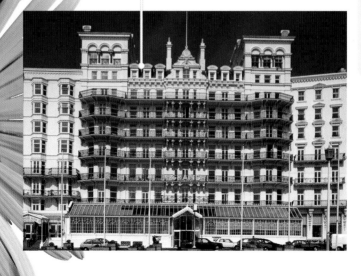

Interchangeable camera lenses have obvious advantages. A wide-angle lens will enable you to get more into the frame of your shot while a telephoto will enable you to magnify subjects which are far away.

Which Lens to Choose?

While different lenses give you more choice, it is important to remember that by changing lenses you are also changing the perspective, the relative sizes of objects in the picture and their spatial relationships.

In general, wide-angle lenses create a sense of 'being there' – of putting the viewer right in the centre of the photograph. The exaggerated perspective offered by these lenses produces a sensation of involvement and adds immediate drama and depth to the image. With wide-angle lenses it is very difficult to find an uncluttered background. Usually, you have to make the background part of the 'story' of your image.

Telephoto lenses produce a more distant, detached feeling. They are ideal for drawing your viewer's attention to specific objects, not least because it is much easier to frame shots with a neutral or complementary background.

TRYING DIFFERENT LENSES AND SETTINGS

 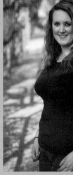

Using a 28mm lens (above, left) includes quite a lot of the background, and requires the photographer to get extremely close to the subject, distorting proportions unattractively.

Using the right length of lens for the effect you want is crucial. Here a 20mm setting was used to give a sense of depth to this shopping centre interior in Dublin, Ireland.

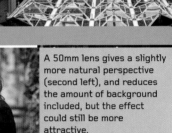

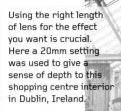

A 50mm lens gives a slightly more natural perspective (second left), and reduces the amount of background included, but the effect could still be more attractive.

Switching to a 'portrait' setting of 100mm helps separate the subject from the background (third left) while producing a more flattering perspective.

The use of a 200mm position on a telephoto zoom (above) puts some distance between the photographer and the subject, creating an appealing perspective.

Zoom lenses may be more versatile than prime lenses, but they are also more complicated to use. Additionally, they are prone to certain conditions which you need to take into account.

Zoom Zoom

Potentially one of the most confusing features of zoom lenses is the way that the maximum aperture of most types changes across the zoom range. Only the most expensive 'professional' zoom lenses have a fixed maximum aperture right across the zoom range. Usually, the maximum aperture is greatest at the wide-angle end of the range and smallest at the telephoto end.

So what happens when you change the focal length after choosing the exposure settings? For example, you might set the camera to shoot at f/3.5 and then zoom in. With modern electronic cameras, the lens will communicate changes in the focal length to the camera body, so that even if you have set an aperture of f/3.5, the camera will automatically update it with the new maximum aperture value as you zoom in, and will adjust the exposure accordingly. However, if you have already zoomed in on your subject before attempting to set the exposure, the camera will limit the maximum aperture you can set to the value available at this zoom setting.

WHICH ZOOM LENS?

'Standard' zoom lenses cover all the focal lengths you would normally use. Typically this will be in the range of 28–90mm for a 35mm film camera and 18–55mm for a digital SLR. A 70–300mm zoom is a good choice as a 'second' lens since it will give you three times the magnification and most are relatively inexpensive. Wide-angle zooms cost more. A 17–35mm lens will give you dramatically increased angles of view.

Zoom lenses are now the norm, and come in a variety of ranges, sizes and prices. Offering economy, flexibility and ease of use, they allow you to frame the picture exactly as you want. As with all photographic equipment, buy the best one you can afford.

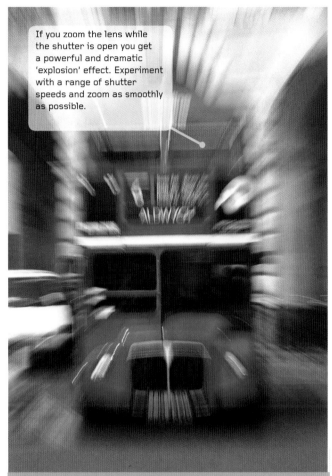

If you zoom the lens while the shutter is open you get a powerful and dramatic 'explosion' effect. Experiment with a range of shutter speeds and zoom as smoothly as possible.

EXPLOSION EFFECTS WITH ZOOM LENSES

You can change the zoom setting during the exposure of your image to produce an 'explosion' effect, in which the centre of the image is comparatively sharp, but the edges appear to be racing out of the frame (see above). To do this, you need to use a shutter speed long enough to give you time to use the zoom control. This might take around a second, so to be sure of a reasonably sharp shot, use a tripod.

Most cameras now come with built-in flashguns, but there are still a number of distinct advantages to fitting an external flashgun, even when the camera already has one built in.

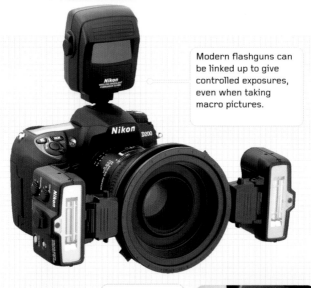

Modern flashguns can be linked up to give controlled exposures, even when taking macro pictures.

Auxiliary flashguns fit on the tops of SLR cameras. They generally deliver far more power and offer a much more attractive light source than integral flashguns.

Most accessory flashguns feature plenty of creative controls that allow you to balance their output with the ambient lighting. Spend some time getting to know your flashgun and exactly what it is capable of.

External Flashguns

External flashguns are much more powerful than those which are fitted to cameras as standard items. Their extra power enables you to photograph subjects that are further away, or to use lower ISOs or smaller lens apertures when you take the shot. Additionally, many external flashguns offer 'swivel' and 'bounce' movements. Direct flash generates harsh lighting, which might be acceptable when there is no alternative, but which is never very attractive. However, if you can turn the flash and 'bounce' it off a nearby wall or ceiling, you will produce a much softer and more natural-looking light in your photograph.

FLASH POWER VALUES

A flashgun's power is quoted as a 'Guide Number' ('GN'), usually set at ISO 100. This offers a useful, standardized measurement of flash power, and this number can also be used for exposure calculations. To work out the lens aperture to use, you divide the Guide Number by the subject distance, in metres. A typical built-in flash might have a GN of 12, so for a subject two metres away the aperture should be 12 divided by 2, or f6. If you think that this sounds complicated, the good news is that in practice modern flashguns carry out these calculations automatically.

THE SECRET TO AVOIDING RED EYE IS TO HAVE PEOPLE LOOKING TOWARDS A LIGHT AS YOU TAKE THE PHOTOGRAPH.

6

BACK-UP

Taking a picture is just the beginning. In order to keep the digital file safe, it needs to be backed up on a computer, hard drive, disc or some other medium. This is especially important when you are out taking pictures in the field. Once it has been transferred to the computer, the next step is to consider how the image can be improved. Many photographers now think of their PC as a digital 'lightroom' — the modern equivalent of the traditional darkroom.

Whereas cameras used to store photographs on film, digital cameras store them as electronic files on memory cards. This is known as image 'capture'. In order to be able to do anything meaningful with your digital images, you also need to be able to transfer them.

Removable storage comes in a bewildering range of types and capacities. For most photographers, though, it is not an issue – you simply buy the type your camera uses.

TRANSFERRING IMAGES

There are two main ways of transferring photos from your camera to your computer. One is to use a 'card reader' (see the box opposite) and the other is to connect the camera to the computer by cable. Most cameras use a USB connection, now universal amongst computers. Some professional models may also offer Firewire, a connection used by Apple Mac computers. It may also be possible to transfer photos 'wirelessly' or, in the case of camera phones, using Bluetooth. Wireless transfer can sometimes be slower and less reliable than cable transfer, as well as being technically problematic.

One of the easiest ways of getting images from your camera to your computer is by using a card reader.

USING A CARD READER

Card readers are small devices that plug into a computer's USB port. You insert your memory card into a slot and it shows up on the computer as an external storage device, so that you can simply drag the photos across into a folder on your computer. You need to make sure that you get a memory card reader that takes the type of card your camera uses, although many card readers include slots for all types.

Memory Cards

Some cameras may come with fixed internal memory as well, but this is usually enough for only a limited number of shots. All cameras have memory card slots. Compact digital cameras with internal memory do not come supplied with memory cards. Compact cameras without internal memory will usually be supplied with a low-capacity card just to get you started. Digital SLRs are sold without memory cards. Memory cards come in several different types. These are SD (Secure Digital), CompactFlash, xD Picture Card and Memory Stick. There is also an older 'Smartmedia' format which is no longer in use.

Many card readers can now read as many as 15 different card types. All you have to do is slot the card into the reader and it appears as a hard drive on the desktop, allowing you to access the images. A quick and easy transfer method.

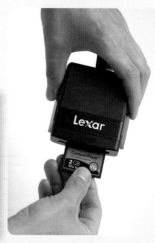

Since most cameras now capture images at high resolution – even as a JPEG this picture of a dog was 2.2Mb – you will need plenty of removable storage.

It is possible to print your photos without a computer with specially designed printers, but a computer is essential for storing and browsing growing photo collections and for editing, enhancing and sharing your images.

If you already have a computer you need to find out whether it is suitable for digital photography. This also applies if you are about to buy a new computer or replace an old one. The main considerations are the processor speed, the memory (RAM) and the storage capacity (hard disk size). Firstly, though, there is an even more basic decision to be taken. Most computer buyers go for PC machines running Microsoft Windows, but while Apple Macintosh computers – 'Macs' – are in a minority, sales are still strong and they have certain advantages

An Apple Macintosh computer can make a very good choice for editing digital photography. These machines feature the special image organizing software, iPhoto, and are robust and easy to use.

Like most contemporary technology, computers are evolving very rapidly. The specifications of even the most humble machines are improving on an almost daily basis. As with anything else in photography, buy the best one you can afford.

Choosing a Monitor

At one time computer monitors were generally of the CRT (cathode ray tube) type with big television-style picture tubes. LCD (liquid crystal displays) were very expensive and comparatively rare. Nowadays, however, LCDs are much cheaper and have largely taken over in the marketplace. LCDs produce a flat, distortion-free image of good quality.

for this kind of work. All Macs come with a program called iPhoto which is extremely good at organizing, cataloguing and enhancing your photos. PCs do not offer an equivalent, although your digital camera may come supplied with similar software. The iMac, iBook and MacBook models come with very good monitors, too, which is an important consideration for photographers.

However, while all cameras and printers work with Macs as well as PCs, there is less choice of software for the Mac, although certain top image editing programs such as Adobe Photoshop and Elements are available for both PC and Mac.

ACCESSORIES

· Printer
For best results choose a 'photo' printer. These produce excellent quality.

· Scanner
You need a scanner if you have a collection of old prints that you want to turn into digital images.

· Card reader
A card reader will make it easier to transfer digital photos to your computer.

· Monitor calibrator
Monitor calibration kits can help ensure that the colours you see on the screen will match those produced in prints of your images.

BACK-UP | PCs, MACS AND LAPTOPS

The Advantages of Using a Laptop

Laptop computers can make excellent alternatives to desktop computers. Apart from their obvious advantages, such as being very compact, easy to pack away and available to work anywhere, laptops also make great portable storage and display devices for photographers.

Broadly speaking, you need two types of software for digital photography: software for organizing and browsing your photos, and software for editing and enhancing them. Sometimes a single program will do both. Even then, though, these jobs are usually split into two distinct areas within the program.

Image Organizing Software

Digital photography software can come from a number of different sources. Most digital cameras are supplied with programs to get you started. Nikon cameras come with PictureProject, for example, which provides basic image organizing and enhancement tools. Kodak provides similar EasyShare software with its cameras, while HP cameras come with ImageZone.

Google's free Picasa 2 application is a very interesting alternative. It is exceptionally fast at finding and browsing digital photos, and incorporates editing tools which are both easy to use and highly effective. If you are on a budget, this is probably the best option to start with. Even basic image organizing programs such as those described above will make a big difference to the way you manage your photographs.

Digital cameras come bundled with software that enables images to be downloaded from the camera to the computer. In most programs, pictures are displayed as thumbnails and can be browsed, opened up and improvements made.

'Photoshop' has almost become a generic name for imaging software, but it is expensive and more sophisticated than many amateurs need – and there are several alternatives that are more economical and just as effective.

Image Editing Software

There are many separate image editing programs to choose from. The most famous (and the most powerful) is Adobe Photoshop, but it is expensive, complicated and has features which many digital photographers will simply never use.

Adobe Photoshop Elements is very much cheaper, easier to use and equipped with most of the tools photographers will need, as well as some for image organizing. Other notable programs in this price bracket include Corel Paint Shop Pro and Ulead PhotoImpact.

UNDERSTANDING PLUG-INS

Many of the special effects you can create in image editing programs are achieved with 'plug-ins'. These are small software 'modules' which are not part of the main program, but which can be invoked from within it just as if they were. These plug-ins are usually found on a 'Filters' or 'Effects' menu.

The majority of the filters in Photoshop and Elements, for example, are plug-ins. These are supplied with the software, but many third-party publishers produce specialized plug-ins for reducing digital noise, improved sharpening of fine detail or creative 'art' effects. These can be bought separately.

Most of the time your digital camera will produce images which are good enough for viewing or printing straight away. It uses the white balance, sharpness and other settings selected on the camera to 'process' the data captured by the sensor into the image stored on the memory card. However, while most digital camera shots are of adequate quality, they can often be improved on your computer.

Correcting Exposure and Colours

Incorrect exposure can lead to images which are either too dark or too light. However, as long as the fault in the original image is not unduly severe, a problem like this can normally be put right using image editing software. Similarly, your photographs may display the wrong colours. For example, pictures of people taken on overcast days or under artificial lighting often suffer from unhealthy-looking skin tones.

FILE TYPES

Digital cameras usually save photographs as 'JPEG' files on the memory card. In JPEG files the image data is compressed so that it takes up less space on the memory card. There is some slight loss of picture quality as a result, but this is rarely visible. Some older cameras can also save TIFF files. These are not compressed. This means that the picture quality is potentially higher.

Again, there is nothing to worry about when it comes to digital images, as a problem like this can be put right without any difficulties on the computer after the picture has been taken.

Improving Framing

It may also be possible to frame your picture more effectively in imaging software on the computer. Perhaps you did not have the time to arrange the perfect composition at the time of shooting and now wish to improve the general presentation of the photograph? The cropping tool in your image editing software will enable you to cut out any unwanted detail at the edges of the frame and, at the same time, you can straighten pictures taken at a slight slant. The latter is a common problem with images of landscapes and buildings, or particularly in the case of photographs of the sea, in which the horizon is in the frame.

Shooting in RAW Format

To give yourself the maximum flexibility for editing your images after taking them, shoot your pictures in RAW format. RAW files offer greater flexibility and image quality because they enable you to choose certain camera settings on your computer later on, including white balance, contrast, sharpness and even exposure compensation. You will often find that the definition and tonal range of your photographs is improved in RAW files, as well. However, RAW files have significant disadvantages, in that they take up extra space on the memory card, they cannot be viewed or printed directly in the same way that JPEGs can and must first be converted into an image file using a 'RAW conversion' program (although many image-editing packages can now process RAW files). Additionally, the RAW file conversion process can be very time-consuming, especially with larger batches of photos.

Many image editing programs can work with images in 'layers'. This enables you to combine or blend different photos. You can think of each layer as a transparent sheet on to which you place an image. Any image on a layer will normally cover up the layers below it, but you can change the opacity to see through.

RAW

When shooting 'RAW' the file becomes a kind of 'digital negative', and with the right software – such as Adobe Lightroom, as shown here – every last drop of quality can be squeezed out of it. Notice how many different controls there are.

Not all pictures are perfect when they come out of the camera. If they were taken in 'portrait' format, you will need first of all to rotate them to the correct orientation.

Correcting Exposure

Exposure problems often arise in difficult lighting conditions, for example when the light is behind the subject (back lighting), or when you are photographing a scene which consists largely of very dark or very light tones. A classic example of the latter might be a black cat in a coal cellar, in which case the cat cannot be easily picked out against the background. In such circumstances, the camera cannot differentiate the subject from the background and can only produce a photograph of average overall brightness. Often, you will only find out that there is a problem when you see the photo on your computer screen and when it appears to be too late to do anything about it. However, one of the great advantages of digital photography is that many exposure errors can be rectified very effectively using image editing software.

LEVELS

A poor, dark image of a wheel hub (above) was massively improved by adjusting the levels in image editing software (right).

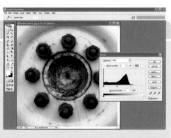

The 'white point' slider was moved to expand the photograph's tonal scale. This introduced proper highlight tones. The 'midtone' slider was also moved to the left in order to increase the photograph's overall brightness and appeal.

CURVES

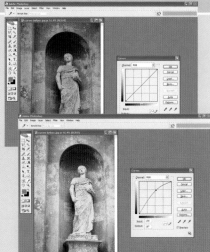

This image of a statue (above) was enhanced through the use of Curves (right).

The photograph was brightened by dragging the curve upwards from somewhere near its centre. This increased the brightness of the shadow areas and midtones.

BRIGHTNESS/CONTRAST

This dark, flat image of flowers (above) was sorted out with the Brightness and Contrast tools in the editing software (right).

By increasing the Contrast the dark and light tones were pushed further apart. Then the Brightness value was also increased.

When you print a photograph, it is scaled to fit the size of the print that you have selected. In the case of digital photos or scans, the pixels in the digital image are scaled up or down according to the print size, but the number of pixels remains the same.

Resizing Images

If you wish your photograph to be displayed on a computer screen, either on a web page or as an email attachment, the picture will need to be resized. This is because the pixels on the computer screen correspond exactly with the pixels in the photo. A photograph from a digital camera might measure 3000 pixels by 2000 pixels, which is far too large for any computer screen. Most have a resolution of around 1024 pixels by 768 pixels. What you need to do in cases like this is to 'resample' the digital photo so that its pixel dimensions match those of computer displays. When doing this, it is important to work on a copy of the photograph, because resampling reduces the detail in the picture and, once this has been done, there is no way back to the higher-resolution original.

When emailing large files it is important to compress them. If not, download speeds can be excessive, even with broadband. This 20.5Mb TIFF file was reduced to an 800Kb JPEG for attachment to a message.

On-screen Image Display

For on-screen display, you need pixel dimensions of around 640 x 480 pixels, or 900 by 600, depending on the size of the screen the pictures will be displayed upon. (Photographs displayed on web pages or in emails need to be smaller than the actual screen size because the program interface takes up much of the space available.) Many image editing programs can automatically resize photographs for on-screen use.

INTERNET FILE FORMATS

The pictures, or 'graphics', you see on web pages fall into two or three categories. Firstly, movies and animations use special file formats which we need not concern ourselves with here. Secondly, diagrams, illustrations and logos commonly use the GIF format. This produces crisp graphics that download quickly, but they are restricted to 256 colours and this format is therefore unsuitable for photographs. Instead, you need to use the JPEG format, which compresses photos so that they download quickly, but still produces good quality.

You can choose various different JPEG compression ratios:

- 'High' quality produces better-looking photos but also larger files.
- 'Medium' quality may be a good compromise with larger photos to make sure they download quickly.
- You may encounter the 'progressive JPEG' format. This is a special type of JPEG file which will display quickly in a web browser but only in a low-resolution form. The full resolution builds up after display.

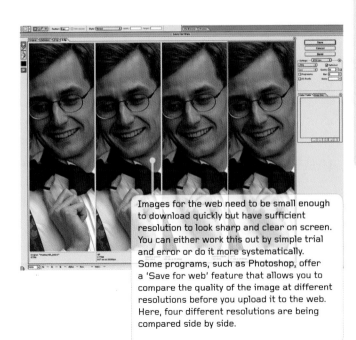

Images for the web need to be small enough to download quickly but have sufficient resolution to look sharp and clear on screen. You can either work this out by simple trial and error or do it more systematically. Some programs, such as Photoshop, offer a 'Save for web' feature that allows you to compare the quality of the image at different resolutions before you upload it to the web. Here, four different resolutions are being compared side by side.

BACK-UP | EMAIL AND IMAGE TRANSFER

Photography is a highly technological subject which is constantly evolving and changing. Consequently, there are many technical terms associated with the medium which you need to understand at least in simple terms if you are to get the best out of your equipment and become a better photographer.

AEB *See* Auto Exposure Bracketing.

AE-Lock Facility that allows the exposure to be locked. Useful in tricky lighting situations to ensure accurate exposure.

Ambient light Any form of constant – as opposed to flash – illumination. Examples include sunlight, moonlight, tungsten bulbs, firelight.

Angle-of-view How much of the scene a lens can see. Wide-angle lenses have a large angle-of-view, telephoto lenses a very narrow angle-of-view.

Aperture-priority mode A shooting mode in which the photographer chooses the lens aperture and the meter provides the complementary shutter speed.

Aperture An adjustable hole formed by the lens diaphragm to control the amount of light that reaches the film.

Array An arrangement of imaging sensors.

Attachment file A digital image, or other attachment, sent with an e-mail.

Auto zoom A handy feature on some flashguns on which the head moves in and out to ensure the flash coverage matches the angle-of-view of the lens.

Available light *See* Ambient Light

Backlighting A situation in which the main illumination comes from behind the subject, creating a silhouette. If this is not desired, flash can be used to add light to the subject.

Back projection System in which a transparency is projected onto a translucent screen to create a backdrop.

Barn doors Set of four flaps that fit over the front of a light and can be adjusted to control the spill of the light.

Bas-relief Artistic technique available as a filter in some image editing computer programs.

Batch processing Automated function in some programs that allows you to make the same set of changes for a series of images.

Boom Long arm fitted with a counterweight which allows heads to be positioned above the subject.

Bounce flash A flash technique whereby the light from a flashgun is bounced off a reflective surface such as a white wall or ceiling. Bounce flash creates a soft, gentle lighting and eliminates the risk of red eye.

Bounce head A flash head that can be tilted and rotated to allow bounce flash photography while the flashgun is mounted on the camera.

Brolly *See* Umbrella.

Brush image Computer software image editing tool that is used to apply different effects.

Built-in flash The pop-up flash unit built into the camera.

Bulb A shutter speed setting available in Manual. When this is set, the shutter remains open for as long as the shutter button is held down.

Burn Selectively darken parts of the image using the Burn tool.

Byte Small unit of computer memory. *See* Kilobyte, Megabyte and Gigabyte.

Camera-shake Lack of image sharpness caused by movement of the photographer's hand.

Capacitor An electrical component that builds up and stores electricity. Used to create the high voltages needed to fire an electronic flash.

Catchlight A sparkle of light in a subject's eyes.

CCD Stands for Charge-coupled device – the sensor in a digital camera that creates the digital image.

Centre-weighted average metering A metering system that takes a light reading from the whole image, but with an emphasis on the central area.

Clone stamp Tool that allows the user to copy part of the image to somewhere else.

Close-up lenses Simple optical accessories that provide an inexpensive entry to the world of close-up photography.

Closest-focusing distance The nearest distance at which a lens can focus.

Close-up mode A Subject Program Selection mode

for photographing near objects.

CMYK Cyan, Magenta, Yellow and Black (K)– combinations of which produce colour images on the printed page.

Colour management The process of controlling the colour of an image through different stages – from capture to print.

Colour temperature The colour of a light source measured in degrees Kelvin.

CompactFlash One of a number of removable and reusable 'digital film' cards.

Compression Process that reduces the size of a digital image so that it requires less storage space, transmits more quickly by e-mail or downloads faster from the internet (*see* JPEG).

Contrast The difference between the lightest and darkest parts of the image.

Coverage angle The angle that the light from a flash spreads. Ideally, this should be the same as, or greater than, the angle-of-view of the camera lens.

CPU Central Processing Unit, another word for Microprocessor.

Crop To cut away parts of the image not required.

Dedicated flashgun A flashgun that is electronically linked to the camera to facilitate exposure control. Early systems merely set film speed on the flashgun and provided a ready light in the viewfinder.

Depth-of-field How much of the finished picture will appear acceptably sharp. This varies in size and depends principally upon the aperture, lens setting and camera-to-subject distance (*see* image below).

Diffuser A material positioned over the flash head to soften the light.

Digitize How a digital image is created – normally by means of a scanner or digital camera.

Dioptric correction lens A viewfinder adjustment that corrects for a range of eyesight deficiencies.

Direct flash A technique where the flash is pointed directly at the subject. Often results in harsh, flat lighting and red eye.

Dodge tool A tool which allows you to selectively lighten areas of the image.

Download Receive a file/image from a remote computer, often via the internet, and generally using a modem (opposite of Upload).

DPI Dots Per Inch – an indication of the resolution of a computer monitor, scanner or printer. The higher the resolution the better the quality.

Duotone A mode that simulates printing with two different coloured inks.

Dynamic range A measure of the spread that can be captured or reproduced by a scanner or printer.

Electronic flashgun A lighting system that uses a capacitor and a gas-filled tube to create a bright flash of light.

Element Individual lens, several of which are combined in groups to produce lenses capable of taking pictures.

Enhancement Improving an image by adjusting contrast, sharpness, colours, and so on.

Existing light *See* ambient light.

Exposure bias Term used in respect of exposure modes, based on whether they give small or large apertures or fast or long shutter speeds.

Exposure compensation A feature of some Minolta cameras that allows the exposure to be increased or decreased by a chosen amount.

Exposure Value (EV) A unit of measurement of light, used as an alternative to shutter speed and aperture. For instance, EV 10 is equivalent to 1/30 sec at f/8.

File format The way in which the image is stored (*See* TIFF, JPEG and GIF.)

Fill-in flash A flash technique used to illuminate shadow areas of a scene already lit by ambient light.

Fill-in Ratio Control A feature on some flashguns that allows the balance of the ambient and flash exposures to be altered. Also called Flash Exposure Compensation.

Film scanner A scanner which is designed to digitize film transparencies and negatives.

Filter Software option for image enhancement.

Firewire High speed computer connection system.

First curtain sync The standard way a flashgun is synchronized to the camera shutter. The flash fires immediately the shutter is fully open. *See* also Second Curtain Sync.

Fish fryer An extremely large softbox.

Flare Image fault caused by light scattering inside a lens – most often occurring when shooting towards the light.

Flash duration The length of a flash emitted from a flashgun.

Flash Exposure Compensation A feature on some cameras and flashguns that allows the balance of the ambient and flash exposures to be altered. Also called Fill-in Ratio Control.

Flash tube A gas-filled glass tube that emits a bright light when a high voltage passes through it. The light source of all electronic flashguns.

Flatbed scanner Scanner designed to digitize flat artwork, such as prints and drawings.

Fluorescent light Continuous light source which often produces a green cast with daylight balanced film – though neutral tubes are also available.

Focal length The optical length of a lens.

Focusing ring The ring found on some cameras that allows manual focusing when the lens is set to manual focus.

Focus Lock Action of the shutter release in which focus is locked while it is held down. Allows accurate focusing with off-centre subjects.

Frame Grabber Device that allows you to 'grab' an image from a video, camcorder, etc.

Full Auto A simple-to-use shooting mode that handles everything for the user.

Gamut The range of colours that can be displayed on a screen or printed on media.

GIF Graphical Interchange Format, used to display images on the net. JPEG is better for photographs, as GIF is limited to 256 colours.

Gigabyte 1024 megabytes, or 1,048,576 bytes, often written as 'Gb'.

Grain The individual silver particles that make up a film image. A grain effect can be added to digital images in the computer.

Grayscale Image consisting of only black and white tones with no colour.

Guide number An indication of the power of a flashgun. By dividing by the flash-to-subject distance, it is possible to calculate the aperture to set for a correct exposure during manual flash photography. Can be quoted in either feet or metres and normally assumes the use of an ISO100 setting.

Hard disk/hard drive Computer hardware that is used for storing images and other files. Some hard disks are built-in, some separate, others removable.

Histogram Graph that shows the tonal distribution of pixels within a digital image.

Honeycomb Grid that fits over a lighting head producing illumination that is harsher and more directional.

Hotshoe A fitting on top of a camera that accepts a flashgun or other accessory.

Image editing software Computer program which can be used to acquire, manipulate and store digital images.

Incident reading Exposure reading of the light falling onto the subject.

Inkjet printer Popular types of colour printer that are capable of producing photo quality prints in various sizes.

Interpolation Process in digital imaging that uses software to add new pixels to an image by analysing adjacent pixels and creating new ones to go between them. This process can reduce quality.

ISO International Standards Organization – sensitivity rating system.

Joule Measure of the output of flash units, equivalent to one watt-second.

JPEG Stands for Joint Photographic Expert Group – the most popular, and useful, image compression format.

Kelvin A unit of measurement of colour temperature.

Key light The main light source.

Landscape mode A Subject Program Selection mode for photographing scenery.

Layers An aspect of most image editing programs which allows you to work on different parts of the image independently.

LCD *See* Liquid Crystal Display.

Light source The origin of any type of light used for photographic purposes, including the sun, reflectors, and flashguns.

Light A visible radiated energy with wavelengths including the colours of the spectrum.

Liquid crystal display (LCD) An electronic device that becomes black when an electronic charge is passed through it. The LCD panel on many cameras displays information about camera settings.

Lith Image in which there are only black and white tones – no colours.

Mac Popular name for Apple Macintosh computers.

Macro lens Technically speaking, a lens which provides a magnification ration of 1:1 (life-size) or greater.

Magic wand Image editing tool which automatically selects areas of similar coloured pixels.

Manual flash A setting on flashguns that gives a fixed-output flash with no TTL control.

Manual focusing Focusing option in which the lens is adjusted by hand – usually with confirmation provided by the viewfinder display.

Manual mode A shooting mode that leaves the photographer to set both the aperture and the shutter speed.

Marquee Tool for selecting part of the image.

Maximum aperture The largest aperture available on a lens, usually indicated by its designation. On most 50mm f/1.8 lenses, for instance, the maximum aperture is f/1.8.

Megabyte 1024 kilobytes, often written as 'Mb'.

Megapixel One million pixels.

Microprocessor The 'brain' of the computer, measured in megahertz.

Minimum aperture The smallest aperture available on a lens – typically f/22, f/27 or f/32.

Mixed lighting Combination of different coloured light sources, such as flash, tungsten or fluorescent.

Mode Way of working – but most commonly indicating exposure mode, the way in which the aperture and shutter speed are selected.

Modelling light Tungsten lamp on a flash head which gives an indication of where the illumination will fall.

Monobloc Self-contained flash head that plugs directly into the mains (unlike flash units, which run from a power pack).

Multiple exposures A feature on some cameras that allows more than one exposure to be made on a single frame of film.

Off-camera flash A technique using a flashgun not mounted on the camera hotshoe.

Optical viewfinder Direct viewing system found on some digital cameras.

Palette A set of tools presented in a small window in computer image editing software.

Partial metering A metering system that takes a light reading from just a small, central part of the image area.

Pixel Short for Picture Element, a tiny square of digital data containing details about resolution, colour and tonal range.

Pixellation Unwanted (usually) effect in which the pixels become so large they are visible to the naked eye.

PL-C Circular polarizing filter which increases subject contrast by controlling light from non-metallic surfaces.

Portrait mode A Subject Program Selection mode for photographing people.

Predictive AF Sophisticated focusing system which anticipates the direction and speed of a moving subject and sets the focus at the moment of exposure to give a sharp result.

Preflash A small flash emitted by some flashguns

to determine the flash-to-subject distance. During direct flash photography the preflash comes from a near-infrared emitter.

Primary colour One of the colours red, blue and green to which the human eye is especially sensitive.

Prime lens One which has a fixed focal length. The opposite of a zoom lens.

Printer Computer peripheral for making hard copy prints.

Program mode A shooting mode in which the camera sets both the shutter speed and the aperture, but the photographer can override some settings.

RAM Random Access Memory.

Ready lamp A light on the back of most flashguns that indicates when the flash is recharged ready to fire.

Recycling time The period after a flashgun fires during which the capacitor recharges ready for the next flash.

Red eye reduction A light shone at the subject by some cameras during built-in flash photography. It helps to reduce the risk of red eye.

Red eye A distinctive effect caused by light from a direct flash entering a subject's eyes and bouncing off red blood vessels behind the retina.

Reflector Any surface that light can be bounced off. Also, a silver surround in the flash head that backs the flash tube.

Resolution Key indicator of the quality of an image, defined by multiplying the number of pixels down by the number of pixels across.

RGB Red, green and blue – the three primary colours used to display images on a computer monitor.

Ringflash Circular flash tube which fits around the lens and produces a characteristic shadowless lighting.

Scanner Item of hardware used to digitize images, with types available for use with prints, slides and negatives.

Second Curtain Sync A setting on some flashguns that causes the flash to fire just before the shutter closes, instead of immediately when the shutter is fully open.

Self-timer A setting on many cameras that delays the firing of the shutter for a few seconds after pressing the shutter button.

Shutter A blind in the camera that opens for a pre-set time to allow light to reach the film.

Shutter release The button pressed to take a photograph.

Shutter-priority mode A shooting mode that allows the photographer to choose the shutter speed.

Shutter speed The time the shutter is open. Most digital cameras have a shutter speed range from around 1 second to 1/1000sec – some wider.

Slave unit A device that senses one flash firing and simultaneously fires a second flash to which it is attached. Does not allow dedicated flash control.

Slow sync flash A technique that combines a flash exposure with a long shutter speed.

Softbox Popular lighting accessory producing extremely soft light. Various sizes and shapes are available – the larger they are the more diffuse the light.

SLR Acronym of Single Lens Reflex. In SLR cameras, a mirror and prism deflect light passing through the lens to the focusing screen so that what you see in the viewfinder is the same image that the film is exposed to when the shutter button is pressed.

Sport mode A Subject Program Selection mode for photographing action.

Spot meter Meter capable of reading from a small area of the subject – typically 1-3°.

Standard lens Lens with a focal length of 50mm.

Standard zoom Lens with a variable focal length around 50mm, typically covering the range from 28/35mm up to 70/80/105mm.

Strobe flash A series of flashes in quick succession, used to record movement. Strobe is short for stroboscopic, not to be confused with the US term for electronic flashgun.

Sync speed The maximum shutter speed that can be used for flash photography on a camera with a focal plane shutter.

Synchronization The method of ensuring that the flash fires when the camera shutter is fully open.

Telephoto lens Lens with a focal length greater than 70mm.

Telezoom Zoom lens whose shortest focal length is 70mm or greater.

Through-the-lens *See* TTL.

Thumbnail Low resolution image found on digital

software and the internet which finds the high resolution files.

TIFF Tagged Image File Format, a popular and high quality file format.

Transparency More formal name for slide film, which is designed to be illuminated from behind.

Transparency adaptor Accessory that allows transparencies to be scanned on a flatbed scanner.

TTL metering Short for Through-The-Lens metering. A meter inside the camera body measures light that has passed through the lens.

Tv An abbreviation of Time Value, and most often used as Tv Mode. Indicates Shutter-priority exposure mode.

Tungsten Continuous light source.

TWAIN Cross-platform interface for acquiring images from scanners.

Umbrella Inexpensive, versatile and portable lighting accessory. Available in white (soft), silver (harsher light), gold (for warming) and blue (for tungsten sources). The larger the umbrella, the softer the light.

USB Abbreviation of Universal Serial Bus, a computer connectivity system that allows many peripherals to be connected to a computer and swapped without the need to 'power down'.

USM 'Unsharp masking' image editing process which improves the apparent sharpness of an image.

UV Ultra-violet filters used to protect the front lens element.

Viewfinder The eyepiece at the back of some SLR cameras that you look through to see the image.

White balance Camera facility which automatically adjusts the colour balance of the picture to compensate for different lighting sources, such as tungsten and fluorescent.

Wide-angle lens Lens with a focal length of 35mm or shorter – for instance 28mm and 24mm.

Zoom Lens on which the focal length can be varied.

Unless you only ever use a direct link from your camera to a printer, it more or less goes without saying that you have access to a computer. It makes sense, therefore, to use it as a portal to the enormous amount of information about digital photography which is available from websites via the internet.

Product Manufacturers

Adobe (Photoshop and more): www.adobe.com
Canon UK's site: www.canon.co.uk/
Compaq: www.hp.com/
Duracell (batteries and more): www.duracell.com
Epson UK's site: www.epson.co.uk/
Fujifilm UK's site: www.fujifilm.co.uk
Gitzo (tripods and monopods, etc.): www.gitzo.com/
Gitzo's UK distributor: www.hasselblad.co.uk/
Hewlett Packard: www.hp.com/
IBM UK's site: www.ibm.com/uk/
InterVideo (WinProducer video editing software and more): www.intervideo.com
Ipswitch (FTP software): www.ipswitch.com
Jasc (Paint Shop Pro and more): www.corel.com
Kodak: www.kodak.com
Macromedia (Dreamweaver web creation software and more): www.macromedia.com
Microsoft (software and more): www.microsoft.com
Nero (CD burning software and other related materials): www.ahead.de/en/index.html
Nikon UK's site: www.nikon.co.uk
Nixvue (handheld storage devices and more): www.nixvue.com
Nokia: www.nokia.com
Pacific Digital (photo frames, etc.): www.pacificdigital.com/
Powerware UK's site (uninterruptible power supplies): www.powerware.com/uk/
Pure Digital (disposable Ritz Dakota cameras): www.puredigitalinc.com
Samsung UK's site: www.samsungelectronics.co.uk
SanDisk (memory cards, readers and more): www.sandisk.com
Sony: www.sony.com/
Ulead (Video Studio software and more): www.ulead.com

Websites for Enthusiasts

A history of photography from its beginnings till the 1920s: www.rleggat.com/photohistory/
A site for Brownie enthusiasts: www.members.aol.com/Chuck02178/brownie.htm
Digital Photography Review (digital photography news and reviews): www.dpreview.com/
Megapixel (monthly digital camera web magazine): www.megapixel.net
Outdoor Eyes (for outdoor Aphotographers): www.outdooreyes.com/
Photo Net (discussion forums, reviews, etc.): www.photo.net/
Shortcourses (a complete digital photography course): www.shortcourses.com/
The Classic Camera: http://www.cosmonet.org/camera/index_e.html